Walter Foster

COLLECTIBLES

HOW TO DRAW & PAINT
FASHION
& costume design

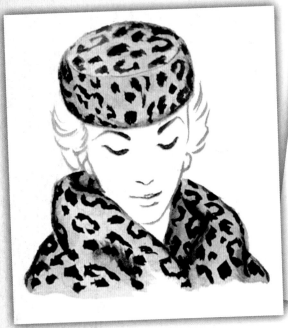

Associate Publisher: Rebecca J. Razo
Project Manager: Michelle Prather
Art Director: Shelley Baugh
Senior Editor: Amanda Weston
Associate Editor: Stephanie Meissner
Production Designers: Debbie Aiken, Amanda Tannen
Production Manager: Nicole Szawlowski
Production Coordinator: Lawrence Marquez
Administrative Assistant: Kate Davidson

www.walterfoster.com
Walter Foster Publishing, Inc.
3 Wrigley, Suite A
Irvine, CA 92618

1 3 5 7 9 10 8 6 4 2

Table of Contents

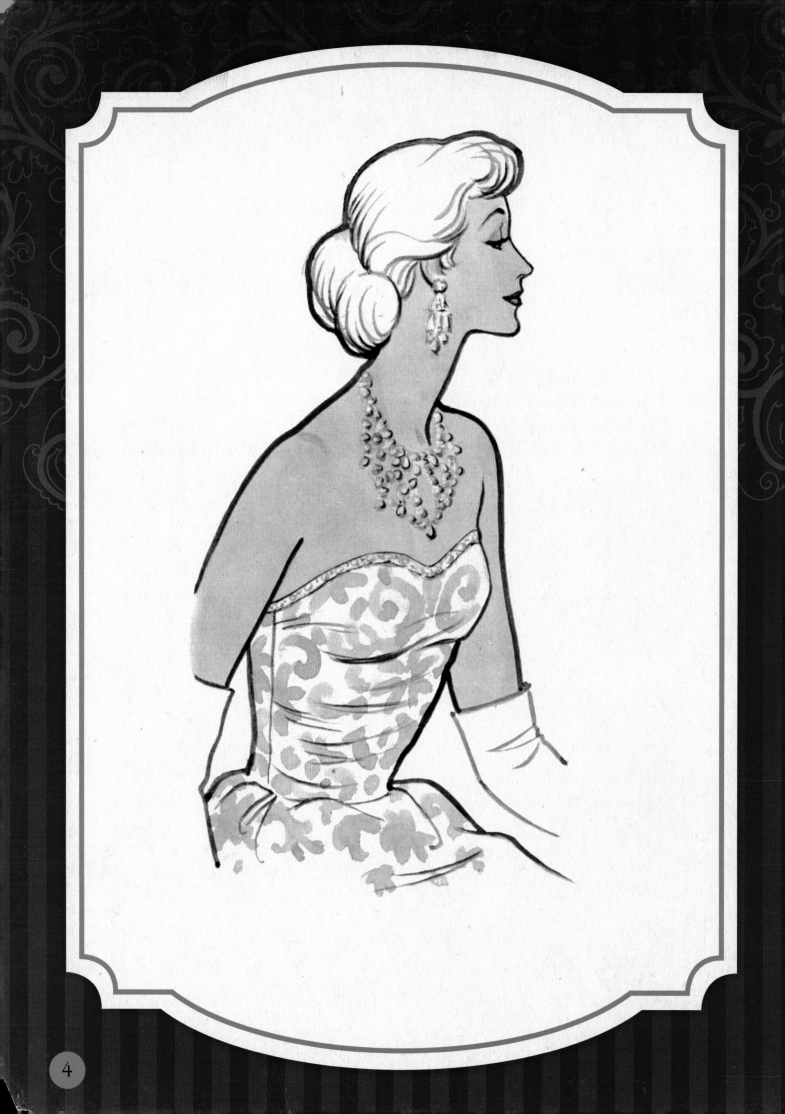

Chapter 1:
Introduction

An impeccably shaped collar, the color and cut of a suit, a smart hat, the seam up the back of a stocking—these seemingly incidental hallmarks of fashion know-how separated trendsetters and tastemakers from the hopelessly dowdy during the 1920s through the early 1960s. Such fashion vanguards as Coco Chanel, Elsa Schiaparelli, Anne Klein, Christian Dior, Hubert de Givenchy, Pierre Cardin, and Mary Quant defined style for a generation of ready-to-wear designers and ensured that "stepping out" meant being pressed and well dressed. *How to Draw & Paint Fashion & Costume Design* resurrects this period of studied sophistication with a dazzling collection of fashion sketches from the Walter Foster archives. With original instruction from Walter T. Foster, Viola French, and Marilyn Sotto, this keepsake book provides everyone from the novice artist to the closet fashion designer abundant artistic inspiration and tips for creating timeless looks using a variety of art media.

Drawing Tools & Materials

On the following pages, you'll learn all about the tools and materials needed to begin drawing and painting the designs featured throughout this book.

DRAWING SUPPLIES

Sketch Pads Sketch pads come in many shapes and sizes. Although most are not designed for finished artwork, they are necessary for working out your ideas.

Paper Drawing paper is available in a range of surface textures: smooth grain (plate finish and hot pressed), medium grain (cold pressed), and rough to very rough. Rough paper is ideal when using charcoal; smooth paper is best for watercolor washes. The heavier the paper, the thicker its weight. Thick paper is better for graphite drawing because it can withstand erasing better than thin paper.

Illustration Board Illustration board is useful for creating artwork that later will be scanned onto other mediums. Unlike Bristol board, it is only finished on one surface. Whether you choose hot press or cold press board depends upon your needs. Use hot press board for pen and ink, wash and watercolor, as it is smoother and produces sharper and finer lines. Use cold press board, which is slightly more textured, for acrylic and ink, wash and watercolor. Its "tooth" is also conducive to charcoal, crayon, and pastel illustrations.

Bristol Board Bristol board is lightweight and is finished on the front and back. Hot press Bristol board best accommodates pen and ink, while cold pressed board is suitable for acrylic and ink. Be sure to choose finer quality archival Bristol board for illustrations you intend to preserve.

Erasers There are several types of art erasers. Plastic erasers are useful for removing hard pencil marks and large areas. Kneaded erasers can be molded into different shapes and used to dab an area, gently lifting tone from the paper.

Tracing and Transfer Paper Tracing and transfer paper are used to transfer the outlines of a photograph or another work to drawing paper or canvas. You can purchase transfer paper that is coated on one side with graphite (similar to carbon paper).

Colored Pencils There are three types of colored pencils: wax based, oil based, and water soluble. Oil-based pencils complement wax pencils nicely. Water-soluble pencils have a gum binder that reacts to water in a manner similar to watercolor. In addition to creating finished art, colored pencils are useful for enhancing small details in a watercolor or pastel painting.

Drawing Pencils

Drawing pencils contain a graphite center. They are sorted by hardness, or grade, from very soft (9B) to very hard (9H). A good starter set includes a 6B, 4B, 2B, HB, B, 2H, 4H, and 6H. Pencil grade is not standardized, so it's best for your first set of pencils to be the same brand for consistency. The chart at right shows a variety of pencils and the kinds of strokes that are achieved with each one. Practice creating different effects with each one by varying the pressure when you draw. Find tools that you like to work with. The more comfortable you are with your tools, the better your drawings will be!

Pencil Key

- Very hard: 5H–9H
- Hard: 3H–4H
- Medium hard: H–2H
- Medium: HB–F
- Medium soft: B–2B
- Soft: 3B–4B
- Very soft: 5B–9B

Pens & Ink

When using ink, remember that hot press illustration board, hot press Bristol board, or pen and ink paper will best accommodate your work.

Pen & Ink Tools

- No. 170 pen
- No. 290 pen
- Quill pen
- Ruling pen
- India ink
- Small camel's hair brush

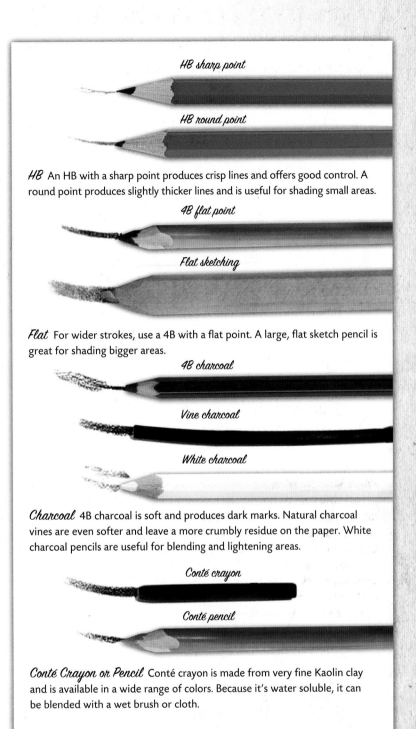

HB sharp point

HB round point

HB An HB with a sharp point produces crisp lines and offers good control. A round point produces slightly thicker lines and is useful for shading small areas.

4B flat point

Flat sketching

Flat For wider strokes, use a 4B with a flat point. A large, flat sketch pencil is great for shading bigger areas.

4B charcoal

Vine charcoal

White charcoal

Charcoal 4B charcoal is soft and produces dark marks. Natural charcoal vines are even softer and leave a more crumbly residue on the paper. White charcoal pencils are useful for blending and lightening areas.

Conté crayon

Conté pencil

Conté Crayon or Pencil Conté crayon is made from very fine Kaolin clay and is available in a wide range of colors. Because it's water soluble, it can be blended with a wet brush or cloth.

Other Drawing Essentials Other tools you may need for drawing include a ruler or T-square for marking the perimeter of your drawing area, an inexpensive drawing board, and artist's tape for attaching paper to your board or a table.

Painting Tools & Materials

OIL & ACRYLIC SUPPLIES

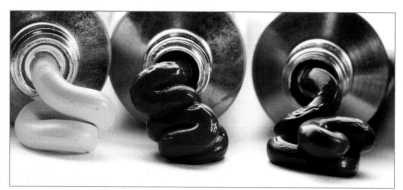

Oil and Acrylic Paint There are several different grades of oil and acrylic paint, including student grade and artist grade. Artist-grade paints are a little more expensive, but they contain better-quality pigment and fewer additives. The colors are also more intense and will stay true longer than student-grade paints.

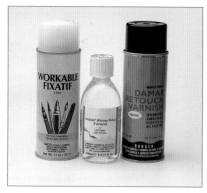

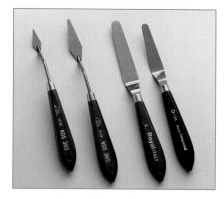

Supports Painting supports usually consist of canvas or wood. You can stretch canvas yourself, but it's much easier to purchase prestretched, primed canvas (stapled to a frame) or canvas board (canvas glued to cardboard). If you choose to work with wood or any other porous material, you must apply a primer first to seal the surface so the oil paints will adhere to the support.

Fixative A fixative helps "set" a drawing and prevents it from smearing. Varnishes are used to protect paintings. Spray-on varnish temporarily sets the paint; a brush-on varnish permanently protects the work. Read the manufacturer's instructions for application guidelines.

Painting and Palette Knives Palette knives can be used to mix paint on your palette or as a tool for applying paint to your support. Painting knives usually have a smaller, diamond-shaped head; palette (mixing) knives usually have a longer, more rectangular blade. Some knives have raised handles, which help prevent you from getting paint on your hand as you work.

Other Oil and Acrylic Essentials Other tools you may need include additives to thin out your oil paint (linseed oil) or to speed drying time (copal), glass or metal containers for additives, an easel, turpentine for cleaning your oil brushes, paper towels, and a mixing palette.

Brushes

Painting brushes vary greatly in size, shape, and texture. The six brushes featured below are perfect for a beginning painter. To preserve the longevity of your brushes, always clean them thoroughly. Use turpentine to clean oil brushes, and use warm, soapy water for acrylic and watercolor brushes. When not in use, store brushes flat or bristle-side up.

Synthetic-Hair Brushes Synthetic brushes are made of nylon or other non-animal products that mimic the qualities of natural hair; they are preferred for use with acrylic paint. The slick bristles of synthetic brushes help the paint slide off easily onto the painting surface. And because paint is easily removed from the bristles, cleanup is more convenient than it is when working with natural-hair brushes. Synthetic brushes come in all shapes and sizes—from thin, delicate bristles that resemble the natural-hair sable brush to thicker, stiffer brushes that imitate the hog-haired bristle brush.

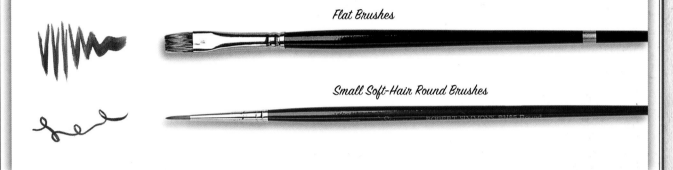

Flat Brushes

Small Soft-Hair Round Brushes

Soft-Hair Brushes Soft-hair brushes are made from the hair of a variety of different animals, including horses, squirrels, oxen, badgers, monkeys, and even skunks. Pure red sable paintbrushes—cut from the hairs of the tail of the kolinsky (a type of mink native to Siberia)—are considered the best type of brush.

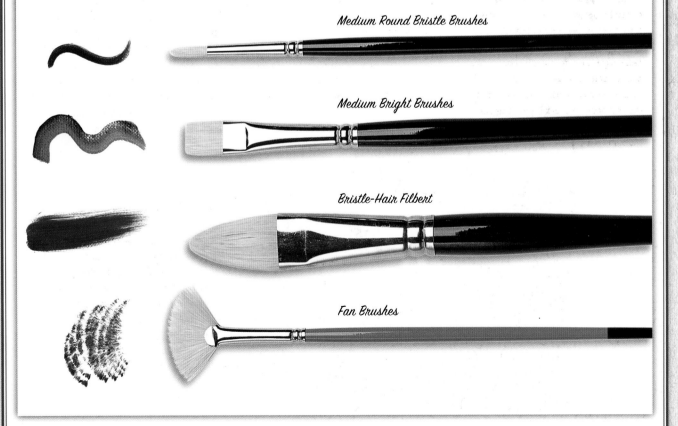

Medium Round Bristle Brushes

Medium Bright Brushes

Bristle-Hair Filbert

Fan Brushes

WATERCOLOR SUPPLIES

Purchasing Watercolors Watercolors are available in pans or tubes. Pans, which are dry or semi-moist cakes of pigment, are best for outdoor painting. Tubes contain moist, squeezable paint and are great for creating large quantities of color. Like oil paint, watercolors come in artist grade and student grade. Artist-quality paints are made with a higher ratio of natural pigments to binders, so they are generally more concentrated and brighter in appearance. Student-quality watercolors use more synthetic pigments or mixes of several types of pigments. These are fine for beginners, but you'll achieve greater quality with the higher-grade artist paint.

Each paint color usually has a lightfast rating of I, II, or III. This rating refers to how much a color will fade under sunlight. A rating of I is the most permanent and III is the least permanent. Some common colors, such as alizarin crimson, are known for fading; however, permanent substitutes are also available.

Other Watercolor Essentials Other useful tools include a paint palette (porcelain or plastic both work well), a container for water, sponges for dabbing, masking fluid, paper towels, and artist's tape.

PASTEL SUPPLIES

Supports The texture and color of the support you choose will affect the outcome of your painting. Because of the delicate nature of soft pastels, you need paper that has some "tooth," or grain, for pigment to stick to. A rough support will "break up" the applied strokes and create texture. A smooth surface, such as paper especially for pastel or watercolor, will make the unbroken colors appear more intense. Pastel supports are available in a variety of colors. You can choose a color that offers a contrasting background tone or one that is in the same color range as your subject.

Purchasing Pastels Pastels come in several forms, including oil pastels; hard, clay-based pastels; and soft pastels, which are chalklike sticks. Soft pastels produce a beautiful, velvety texture and are easy to blend with your fingers, a chamois, or soft cloth. When purchasing pastels, keep in mind that colors are mixed on the paper as you paint; therefore, it is helpful to buy a wide range of colors in various "values"—lights, mediums, and darks—so that you will always have the color you want readily available.

Other Pastel Essentials Other helpful tools include scissors to trim supports, vine charcoal to lay out designs, a sandpaper block to sharpen pastel sticks, a paper stump for blending, and a razor blade to break pastels off cleanly. You can also paint over your work with denatured alcohol on a soft brush to wash the color thoroughly into the paper.

Color Theory

Knowing a little about basic color theory can help you tremendously when painting in oil, watercolor, or pastel or when drawing with colored pencils. The primary colors (red, yellow, and blue) are the three basic colors that cannot be created by mixing other colors; all other colors are derived from these three. Secondary colors (orange, green, and purple) are each a combination of two primaries. Tertiary colors (red-orange, red-purple, yellow-orange, yellow-green, blue-green, and blue-purple) are a combination of a primary color and an adjacent secondary color.

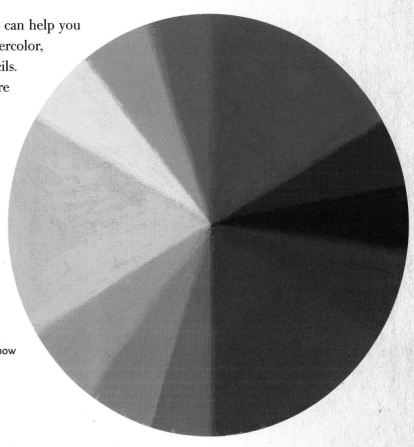

Color Wheel Knowing where each color lies on the color wheel will help you understand how colors relate to and interact with one another; it will also help you understand how to mix and blend your own hues.

Complementary Colors

Complementary colors are any two colors directly across from each other on the color wheel (such as red and green, orange and blue, or yellow and purple).

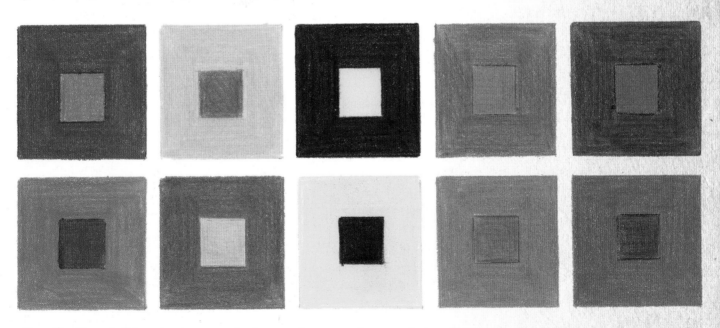

Using Complements When placed next to each other, complementary colors create lively, exciting contrasts. Using a complementary color in the background will cause your subject to "pop." For example, you could place bright orange poppies against a blue sky, or you could draw red berries amid green leaves.

Form & Value

Drawing consists of three main elements: line, shape, and form. The shape of an object can be described with a simple one-dimensional line. The three-dimensional version of the shape is known as the object's form. In pencil drawing, variations in *value* (the relative lightness or darkness of black or a color) describe *form*, giving an object the illusion of depth. In pencil drawing, values range from black (the darkest value) through different shades of gray to white (the lightest value). To make a two-dimensional object appear three-dimensional, you must pay attention to the values of the highlights and shadows. When shading a subject, consider the light source, as this is what determines where highlights and shadows will be.

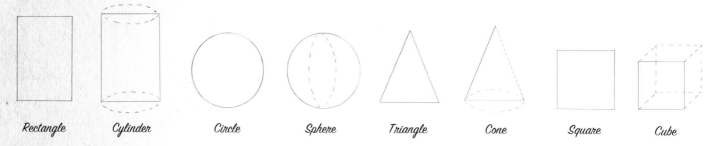

Rectangle　　　Cylinder　　　Circle　　　Sphere　　　Triangle　　　Cone　　　Square　　　Cube

Moving from Shape to Form　The first step in creating an object is establishing a line drawing or outline to delineate the flat area that the object takes up. This is known as the "shape" of the object. The four basic shapes—the rectangle, circle, triangle, and square—can appear to be three-dimensional by adding a few carefully placed lines that suggest additional planes. By adding ellipses to the rectangle, circle, and triangle, you've given the shapes dimension and have begun to produce a form within space. Now the shapes are a cylinder, sphere, and cone. Add a second square above and to the side of the first square, connect them with parallel lines, and you have a cube.

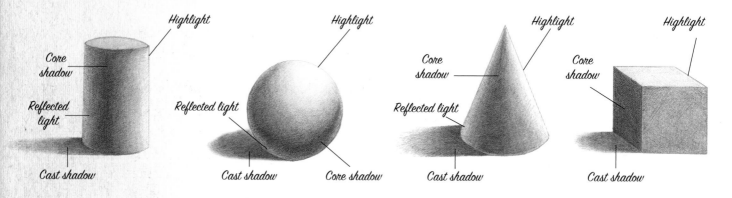

Adding Value to Create Form　A shape can be further defined by showing how light hits the object to create highlights and shadows. Note from which direction the source of light is coming; then add the shadows accordingly. The core shadow is the darkest area on the object and is opposite the light source. The cast shadow is what is thrown onto a nearby surface by the object. The highlight is the lightest area on the object, where the reflection of light is strongest. Reflected light is the surrounding light reflected into the shadowed area of an object.

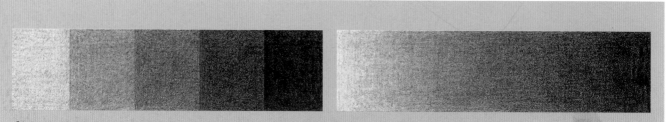

Creating Value Scales　Just as a musician uses a musical scale to measure a range of notes, an artist uses a value scale to measure changes in value. You can refer to the value scale so you'll always know how dark to make your dark values and how light to make your highlights. The scale also serves as a guide for transitioning from lighter to darker shades. Making your own value scale will help familiarize you with the different variations in value. Work from light to dark, adding more and more tone for successively darker values (as shown above left). Then create a blended value scale (as shown above right). You can use a tortillon to smudge and blend each value into its neighboring value from light to dark to create a gradation.

Basic Drawing Techniques

You can create a variety of effects, lines, and strokes with pencil simply by alternating hand positions and shading techniques. Many artists use two main hand positions for drawing. The writing position is good for detailed work that requires hand control. The underhand position allows for a freer stroke with arm movement and motion that is similar to painting.

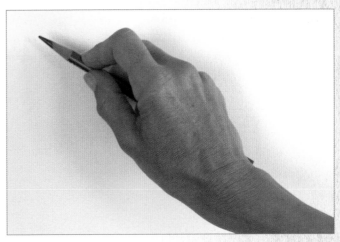

The Writing Position The writing position provides the most control in which to produce accurate, precise lines for rendering fine details and accents. When your hand is in this position, place a clean sheet of paper under it to prevent smudging.

The Underhand Position Place your hand over the pencil and grasp it between the thumb and index finger. Allow your other fingers to rest alongside the pencil. This position is great for creating beautiful shading effects and long, sweeping lines.

Shading Techniques

The shading techniques below can help you learn to render everything from a smooth complexion and straight hair to shadowed features and simple backgrounds. Whatever techniques you use, always remember to shade evenly.

Hatching This basic method of shading involves filling an area with a series of parallel strokes. The closer the strokes, the darker the tone.

Crosshatching For darker shading, place layers of parallel strokes on top of one another at varying angles. Again, make darker values by placing the strokes closer together.

Gradating To create graduated values (from dark to light), apply heavy pressure with the side of your pencil, gradually lightening the pressure as you stroke.

Shading Darkly By applying heavy pressure to the pencil, you can create dark, linear areas of shading.

Shading with Texture For a mottled texture, use the side of the pencil tip to apply small, uneven strokes.

Blending To smooth out the transitions between strokes, gently rub the lines with a tortillon or tissue.

Practicing Lines

When drawing lines, it is not necessary to always use a sharp point. In fact, sometimes a blunt point may create a more desirable effect. When using larger lead diameters, the effect of a blunt point is even more evident. Play around with your pencils to familiarize yourself with the different types of lines they can create. For more about the different types of drawing pencils, see page 7.

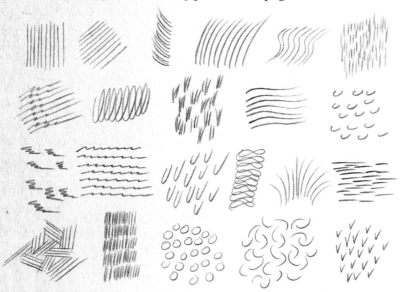

Drawing with a Sharp Point The lines at left were drawn with a sharp point. Draw parallel, curved, wavy, and spiral lines; then practice varying the weight of the lines as you draw. Os, Vs, and Us are some of the most common alphabet shapes used in drawing.

Drawing with a Blunt Point The shapes at right were drawn using a blunt point. Note how the blunt point produced different images. You can create a blunt point by rubbing the tip of the pencil on a sandpaper block or on a rough piece of paper.

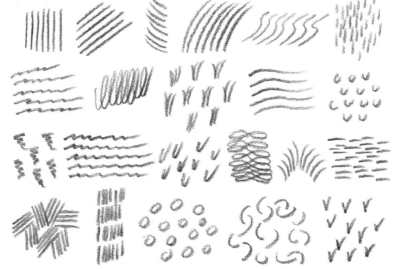

"Painting" with Pencil

When you use painterly strokes, your drawing will take on a new dimension. Think of your pencil as a brush and allow yourself to put more of your arm into the stroke. The larger the lead, the wider the stroke; the softer the lead, the more painterly the effect. The examples shown here were drawn on smooth paper with a 6B pencil, but you can experiment with rough paper for more broken effects.

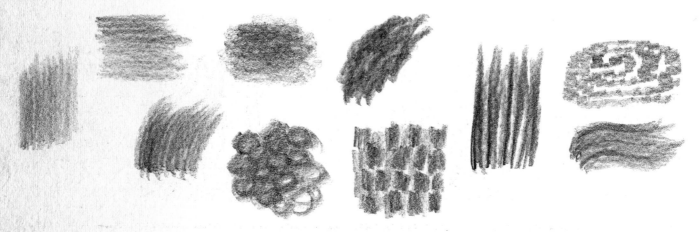

Finding Your Style

Many great artists of the past can now be identified by their unique experiments with line. Vincent van Gogh's drawings were a feast of calligraphic lines; Seurat became synonymous with pointillism; and Giacometti was famous for his scribble. Can you find your identity in a pencil stroke?

Using Criss-Crossed Strokes
If you like a lot of fine detail, you'll find that crosshatching allows you a lot of control. You can adjust the depth of your shading by changing the distance between your strokes.

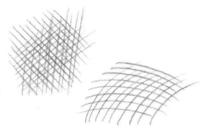

Sketching Circular Scribbles
If you work with round, loose strokes, you are probably experimental with your art. These looping lines suggest a free-form style that is more concerned with evoking a mood than with capturing precise details.

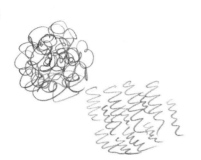

Drawing Small Dots
This technique, called "stippling," uses many small dots to create a larger picture. Make the points different sizes to create various depths and shading effects.

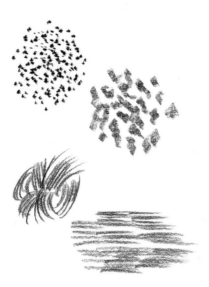

Simulating Brushstrokes
You can create the illusion of brushstrokes by using short, sweeping lines. These strokes are ideal for a more stylistic approach.

Working with Different Techniques

Below are several more techniques that can be created with pencil. You will need both soft and hard pencils for these exercises.

Creating Washes
First shade an area with a water-soluble pencil. (This is a pencil that produces washes similar to watercolor paint when manipulated with water.) Blend the shading with a wet brush. Make sure your brush isn't too wet, and use thick paper, such as vellum board.

Rubbing
Place paper over an object and rub the side of your pencil lead over the paper. The strokes of your pencil will pick up the pattern underneath and replicate it on the paper. Try using a soft pencil on smooth paper, and choose an object with a strong textural pattern, such as a wire grid, as shown at left.

Lifting Out
Blend a soft pencil on smooth paper, and then lift out the desired area with a kneaded eraser. You can create highlights and other interesting effects with this technique.

Producing Indented Lines
"Draw" a pattern or design with a sharp, non-marking object such as a knitting needle. Next, shade over the area with the side of your pencil to reveal the pattern.

Smudging

Smudging is an important technique for creating shading and gradients. Use a tortillon or chamois cloth to blend your strokes. It is important that you do not use your finger, because your hand has natural oils that can damage your art.

Smudging on Rough Surfaces
For a granular effect, use a 6B pencil on vellum-finish Bristol board. Stroke with the side of the pencil; then blend with a tortillon.

Smudging on Smooth Surfaces
Use a 4B pencil on plate-finish Bristol board. Stroke with the side of the pencil; then blend with a tortillon.

Colored Pencil Techniques

Colored pencil is amazingly satisfying to work with, partly because it's so easily manipulated and controlled. The way you sharpen your pencil, the way you hold it, and the amount of pressure you apply all affect the strokes you create. With colored pencils, you can create everything from soft blends to brilliant highlights to realistic textures. Once you get the basics down, you'll be able to decide which techniques will capture your subject's unique qualities. There are as many techniques in the art of colored pencil as there are effects—and the more you practice and experiment, the more potential you will see in the images that inspire you.

Pressure

Colored pencil is not like paint: You can't just add more color to the tip when you want it to be darker. Because of this, your main tool is the amount of pressure you use to apply the color. It is always best to start light so that you maintain the tooth of the paper for as long as you can. Through practice, you will develop the innate ability to change the pressure on the pencil in response to the desired effect.

Light Pressure Here color was applied by just whispering a sharp pencil over the paper's surface. With light pressure, the color is almost transparent.

Medium Pressure This middle range creates a good foundation for layering. This is also the pressure you might want to use when signing your drawings.

Heavy Pressure Really pushing down on the pencil flattens the paper's texture, making the color appear almost solid.

Strokes

Each line you make in colored pencil drawing is important—and the direction, width, and texture of the line you draw will contribute to the effects you create. Practice making different types of strokes. You'll find that you have a natural tendency toward one or two strokes in particular, but any stroke you use can help convey texture and emotion in your work.

Strokes and Texture You can imitate a number of different textures by creating patterns of dots and dashes on the paper. To create dense, even dots, try twisting the point of your pencil on the paper.

Strokes and Movement While a group of straight lines can suggest direction (above left), a group of slightly curved lines (above right) conveys a sense of motion more clearly. Try combining a variety of strokes to create a more turbulent, busy design. Exercises like these can give you an idea of how the lines and strokes you draw can be expressive as well as descriptive.

Varied Line Try varying the width and weight of the lines you create to make them more textured and interesting. These

Types of Strokes

Circular Move your pencil in a circular motion, either in a random manner as shown here or in patterned rows. For denser coverage as shown on the right side of the example, overlap the circles. You can also vary the pressure throughout for a more random appearance.

Linear It may be more comfortable for you to work in a linear fashion: vertically, horizontally, or diagonally, depending on your preference. Your strokes can be short and choppy or long and even, depending on the texture desired.

Scumbling This effect is created by scribbling your pencil over the surface of the paper in a random manner, creating an organic mass of color. Changing the pressure and the amount of time you linger over the same area can increase or decrease the value of the color.

Hatching This term refers to creating a series of roughly parallel lines. The closer the lines are together, the denser and darker the color. Crosshatching is laying one set of hatched lines over another but in a different direction. You can use both of these strokes

Smooth No matter what your favorite stroke is, you should strive to be able to control the pencil and apply a smooth, even layer of color. Small circles are shown in this example. Note that when the color is smooth you can't tell how it was applied.

Stippling This is a more mechanical way of applying color, but it creates a very strong texture. Simply sharpen your pencil and create small dots all over the area. Make the dots closer together for denser coverage.

17

Oil & Acrylic Techniques

There are myriad techniques and tools that can be used to create a variety of textures and effects. By employing some of these different techniques, you can spice up your art and keep the painting process fresh, exciting, and fun! The examples on these pages were completed using acrylic paint.

Flat Wash This thin mixture of acrylic paint has been diluted with water (use solvents to dilute oil paint). Lightly sweep overlapping, horizontal strokes across the support.

Graded Wash Add more water or solvent and less pigment as you work your way down. Graded washes are great for creating interesting backgrounds.

Save Time—Plan Ahead!

Sketching Your Subject Taking an extra moment to prepare before you paint will ensure successful results and will save you time. For example, make a sketch of your subject before you begin applying washes.

Taking Precautions Keep tools on hand that might be helpful, like a ruler, artist's triangle, or straightedge that can be used as a guide. And be sure to have paper towels and lint-free rags handy.

Thick on Thin Stroking a thick application of paint over a thin wash, letting the undercolor peek through, produces textured color variances perfect for rough or worn surfaces.

Dry on Wet Create a heavily diluted wash of paint; then, before the paint has dried, dip a dry brush in a second color and stroke quickly over it to produce a grainy look.

Impasto Use a paintbrush or a painting knife to apply thick, varied strokes, creating ridges of paint. This technique can be used to punctuate highlights in a painting.

Scumble With a dry brush, lightly scrub semi-opaque color over dry paint, allowing the underlying colors to show through. This is excellent for conveying depth.

Stipple Take a stiff brush and hold it very straight, with the bristle-side down. Then dab on the color quickly, in short, circular motions. Stipple to create the illusion of reflections.

Scrape Using the side of a palette knife or painting knife, create grooves and indentations of various shapes and sizes in wet paint. This works well for creating rough textures.

Mask with Tape Masking tape can be placed onto and removed from dried acrylic paint without causing damage. Don't paint too thickly on the edges—you won't get a clean lift.

Lifting Out Use a moistened brush or a tissue to press down on a support and lift colors out of a wet wash. If the wash is dry, wet the desired area and lift out with a paper towel.

Drybrush Use a worn flat or fan brush loaded with thick paint, wipe it on a paper towel to remove moisture, then apply it to the surface using quick, light, irregular strokes.

19

Watercolor Techniques

Transparent watercolor relies on the white of the paper and the translucency of the pigment to communicate light and brightness. A well-painted watercolor seems to glow with an inner illumination that no other medium can capture. The best way to make your paintings vibrant and full of energy is to mix most of your colors on the paper while you are painting the picture. Although it seems counter-intuitive to what you may have been taught, allowing the colors to mix together on the paper, with the help of gravity, can create dynamic results. It is accidental to a certain degree, but if your values and composition are under control, these unexpected color areas will be successful and exciting.

Wet on Dry

This method involves applying different washes of color on dry watercolor paper and allowing the colors to intermingle, creating interesting edges and blends.

Mixing in the Palette vs. Mixing Wet on Dry
To experience the difference between mixing in the palette and mixing on the paper, create two purple shadow samples. Mix ultramarine blue and alizarin crimson in your palette until you get a rich purple; then paint a swatch on dry watercolor paper (near right). Next paint a swatch of ultramarine blue on dry watercolor paper. While this is still wet, add alizarin crimson to the lower part of the blue wash, and watch the colors connect and blend (far right). Compare the two swatches. The one at the right uses the same paints but has the added energy of the colors mixing and moving on the paper.

Variegated Wash

A variegated wash differs from the wet-on-dry technique in that wet washes of color are applied to wet paper instead of dry paper. The results are similar, but using wet paper creates a smoother blend of color. Using clear water, stroke over the area you want to paint and let it begin to dry. When it is just damp, add washes of color and watch them mix, tilting your paper slightly to encourage the process.

Applying a Variegated Wash After applying clear water to your paper, stroke on a wash of ultramarine blue (near right). Immediately add some alizarin crimson to the wash (right center), and then tilt to blend the colors further (far right). Compare this with your wet-on-dry purple shadow to see the subtle differences caused by the initial wash of water on the paper.

Wet into Wet

This technique is like the variegated wash, but the paper must be thoroughly soaked with water before you apply any color. The saturated paper allows the color to spread quickly, easily, and softly across the paper. Begin by generously stroking clear water over the area you want to paint, and wait for it to soak in. When the surface takes on a matte sheen, apply another layer of water. When the paper again takes on a matte sheen, apply washes of color and watch the colors spread.

Painting Wet into Wet Loosely wet the area you want to paint. After the water soaks in, follow up with another layer of water and wait again for the matte sheen. Apply ultramarine blue to your paper, both to the wet and dry areas of the paper. Now add a different blue, such as cobalt or cerulean, and leave some paper areas white (far left). Now add some raw sienna (left center) and a touch of alizarin crimson (near left). The wet areas of the paper will yield smooth, blended, light washes, while the dry areas will allow for a darker, hard-edged expression of paint.

Glazing

Glazing involves applying two or more washes of color in layers to create a luminous, atmospheric effect. Glazing unifies the painting by providing an overall underpainting (or background wash) of consistent color.

Creating a Glaze To create a glazed wash, paint a layer of ultramarine blue on wet or dry paper (near right). After this wash dries, apply a wash of alizarin crimson over it (far right). The subtly mottled purple that results is made up of individual glazes of transparent color.

Pastel Techniques

Applying Unblended Strokes In this example, magenta is layered loosely over a yellow background. The strokes are not blended together, and yet from a distance the color appears orange—a mix of the two colors.

Blending with Fingers Using your fingers or the side of your hand to blend gives you the softest blend and the most control, but be sure to wipe your hands after each stroke so you don't muddy your work.

Blending with a Tortillon For blending small areas, some artists use a paper blending stump, or tortillon. Use the point to soften details and to reach areas that require precise attention.

Using a Cloth For a large background, it is sometimes helpful to use a cloth or a paper towel to blend the colors. To lighten an area, remove the powdery excess pastel by wiping it off with a soft paper towel.

Removing Pigment When you need to remove color from a given area, use a kneaded eraser to pick up the pigment. The more pressure you apply, the more pigment will be removed. Keep stretching and kneading the eraser to expose new, clean surfaces.

Creating Patterns To create textures or patterns, first lay down a solid layer of color using the side of the pastel stick or pencil. Then use the point of a pastel pencil to draw a pattern, using several different colors if you wish.

Using Tape You can create straight, even edges by using house painter's tape. Just apply it to your support, and make sure the edges are pressed down securely. Apply the pastel as you desire, and then peel off the tape to reveal the straight edges.

Gradating on a Textured Support Creating a smooth, even gradation on a textured ground can be a little tricky. Add the colors one at a time, applying the length of the stick and letting it skip over the texture of the paper by using light pressure.

Glazing Create a "glaze" just as you might with watercolor by layering one color over another. Use the length of the pastel stick with light pressure to skim over the paper lightly. The result is a new hue—a smooth blend of the two colors.

21

People in Perspective

To practice perspective, try drawing a frontal view of many heads as if they were people sitting in a theater. Start by establishing your vanishing point at eye level. Draw one large head representing the person closest to you, and use it as a reference for determining the sizes of the other figures in the drawing. Keep in mind that a composition also can have two or more vanishing points.

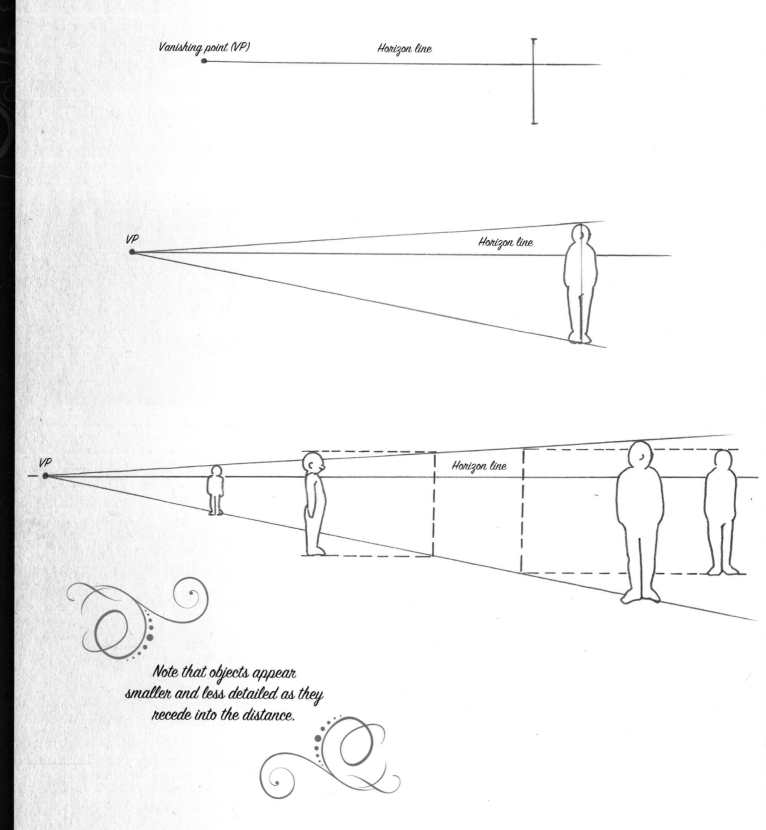

Note that objects appear smaller and less detailed as they recede into the distance.

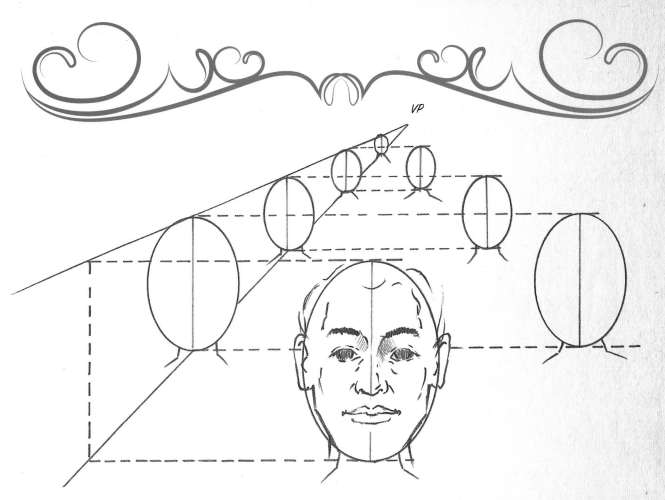

If you're a beginner, you may want to begin with basic one-point perspective. As you progress, attempt to incorporate two- or three-point perspective.

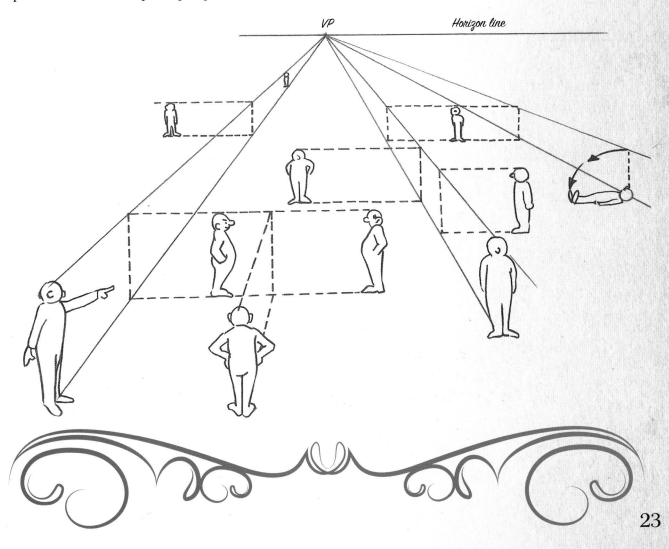

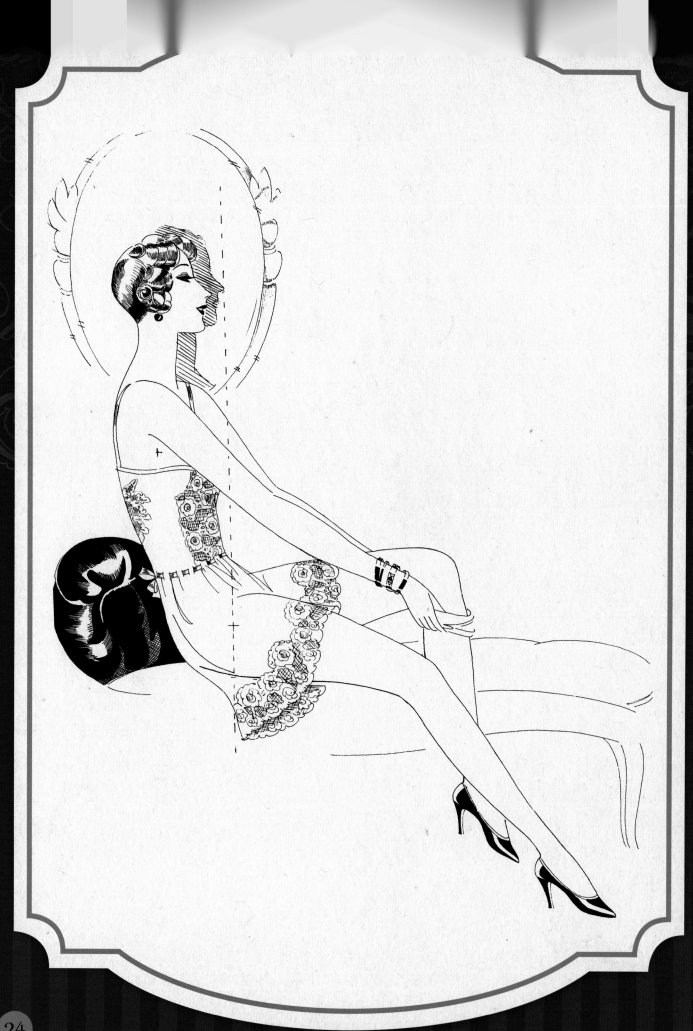

Chapter 2:
1920s–1930s
Male & Female Fashions
with Walter T. Foster

The 1920s kicked off an electrifying period in fashion, particularly for women. Disposable income was on the rise, especially for women who took work as shop girls and secretaries. And thanks to innovations in the mass production of clothing, quality came cheaper than ever before. Androgynous, liberated flappers shimmied the nights away to a jazz soundtrack while throngs of men, eager to take on the modern age with youth and athleticism, donned suits of tweed or flannel, often with cuffed trousers and a snazzy pair of winged tips. By the 1930s, Hollywood and its escapist imagery infiltrated fashion houses, making the decade a glamorous one, despite the Great Depression. Women adopted a more feminine style that accentuated their curves. A day look would be understated and ladylike, and evening attire chic to the hilt. Film icons like Fred Astaire and Gary Cooper set the bar for men's style, making suits with tapered trousers and Fedora hats the ultimate staples of cool.

Heads

The styling of a fashion figure's head sets the tone for the rest of the design. Practice drawing female and male heads in different positions, keeping in mind that blocking in with pencil first makes inking in far easier.

1 *2* *3*

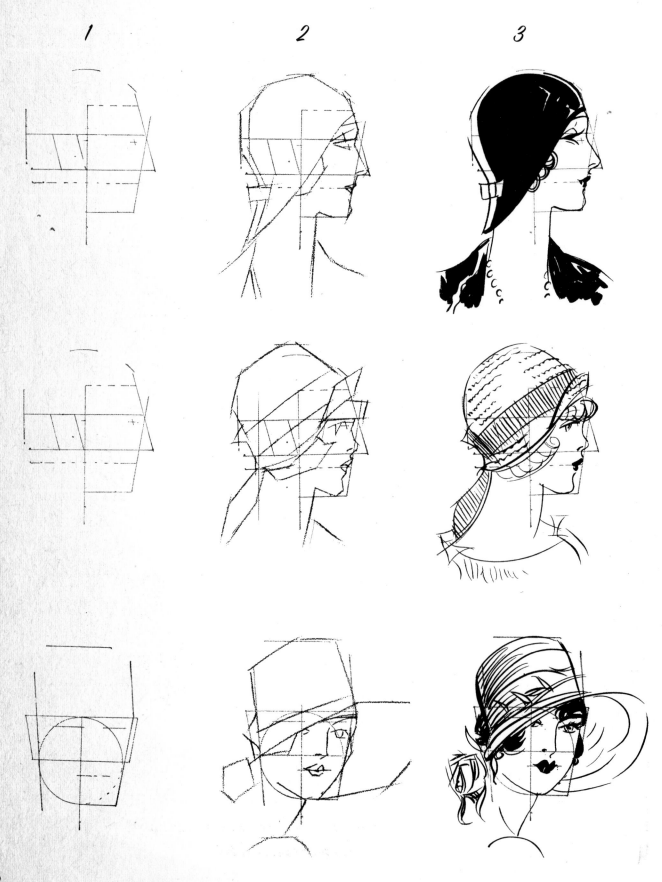

1　　　　　*2*　　　　　*3*

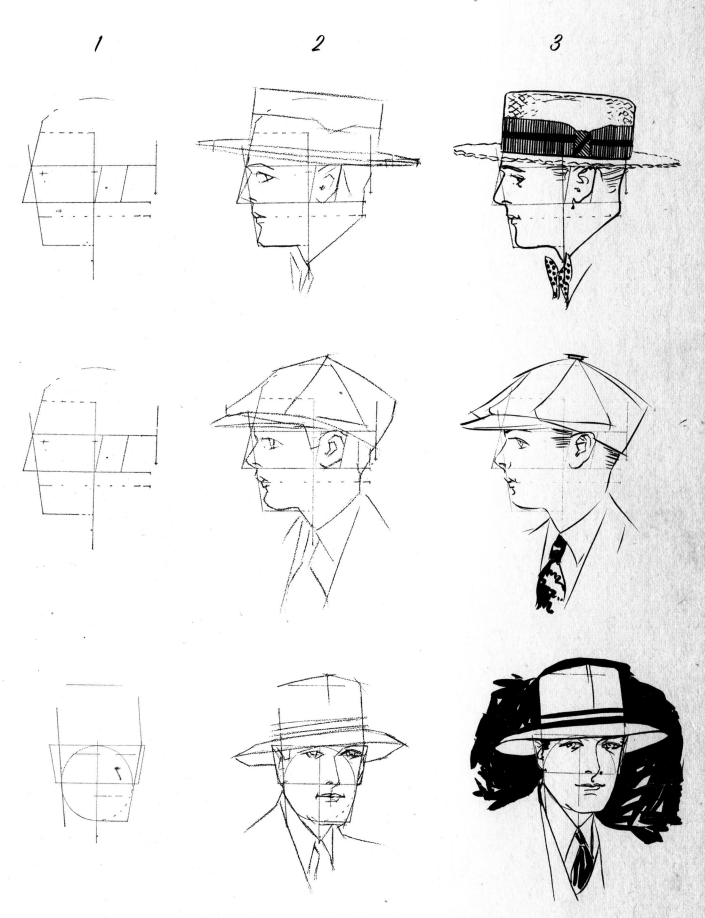

*You can use these basic shapes as the starting
point for a variety of looks.*

Hands & Feet

Regardless of talent, drawing requires coordination of the mind, eye, and hand, and the understanding and execution to achieve it. It is better to think and draw one line than to scratch in several lines haphazardly and have them confuse you. If you make a mistake, simply erase and draw the lines where they should be.

Always add the thumb and fingers last.

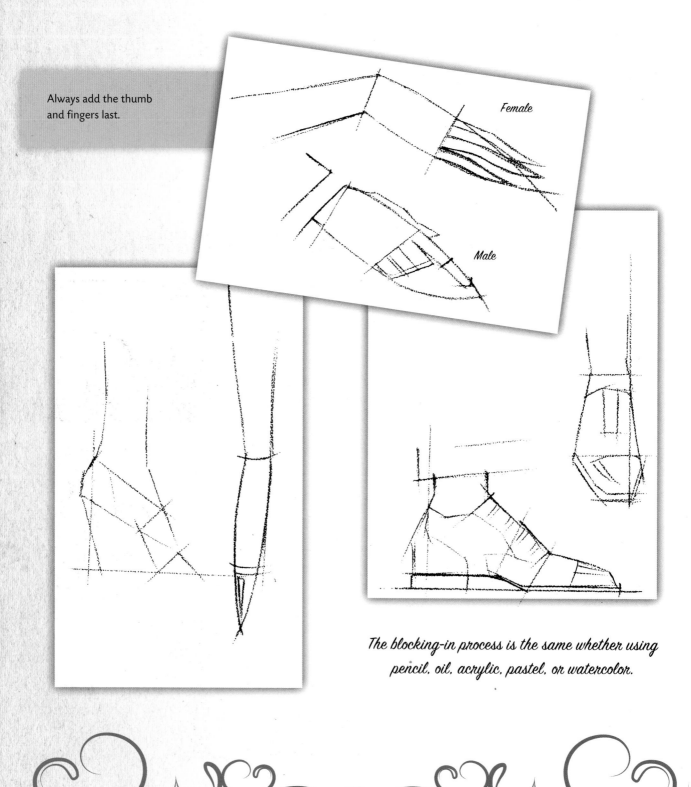

Female

Male

The blocking-in process is the same whether using pencil, oil, acrylic, pastel, or watercolor.

*When drawing shoes, the back of the heel extends
to or in front of the line of balance.*

1

2

3

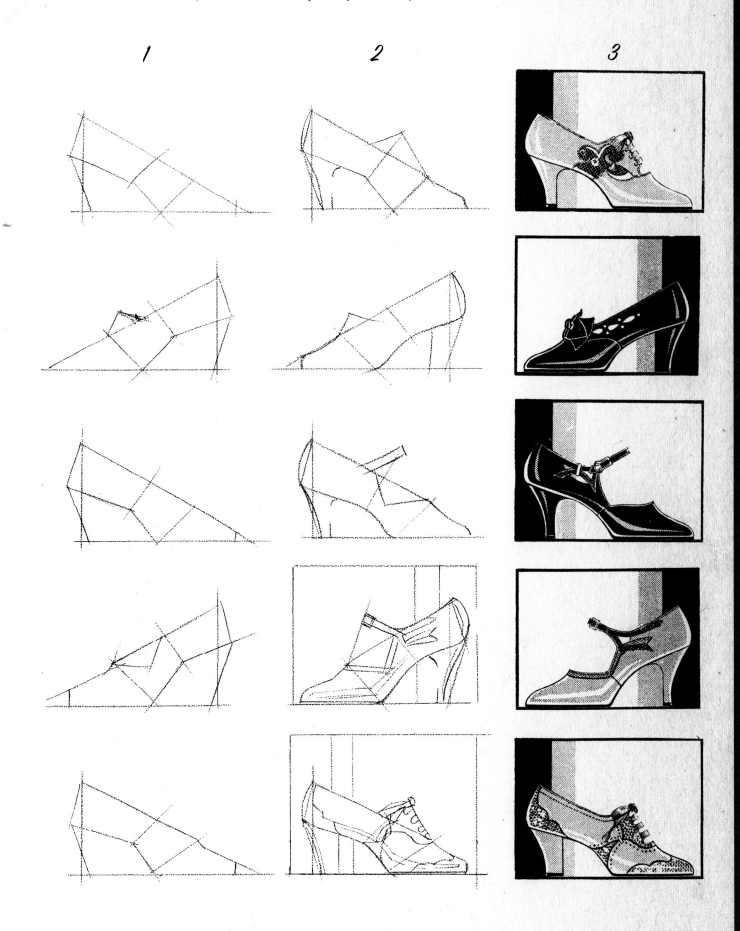

The Male Figure

1. Draw a vertical line, then divide it into eight heads numbered 2, 4, 6, and 8. Divide the second head into fourths. Three-quarters gives you the neckline.

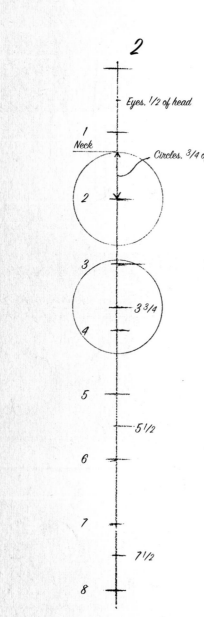

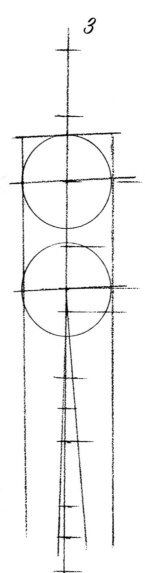

2 Eyes. 1/2 of head

Neck

Circles. 3/4 of head

2

3

3 3/4

4

5

5 1/2

6

7

7 1/2

8

Place the point of a compass on 2 and extend it to the neckline. This will give you the size of the circle. Make the circles larger or smaller, depending on the desired physique.

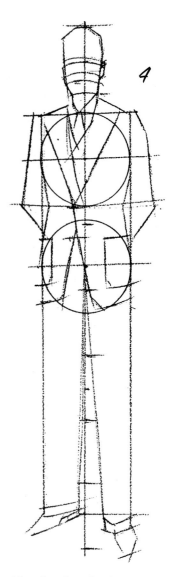

3

Draw a horizontal line at the neck and vertical lines that touch the outsides of the circles to mark the shoulders and hips. If the figure is standing on the right foot, the right hip should go up and the right shoulder down. The center of the circle moves to the right of the line of balance.

4

Now draw lines for the body and then add the arms. Note the elbows are at 2¾ heads on male figures. The knees are at 5½ heads, and the heels are at 7½ heads. Draw lines for the neck, eye, and chin line.

30

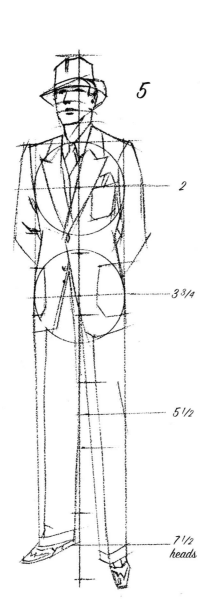

5

Add details, such as a hat, wingtips, coat pockets and lapels, and facial features.

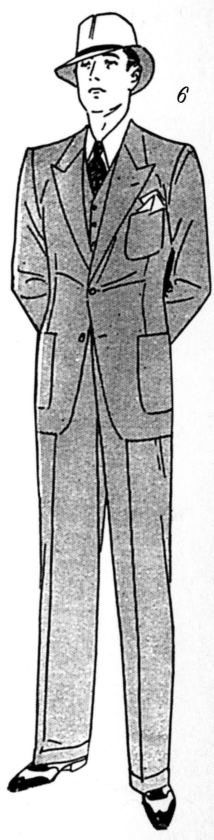

6

The center of the neck and ankle are always on the line of balance (or vertical line) unless the figure is standing on both feet or in action. I made this figure with a No. 170 pen point and added the black with a No. 3 brush.

The Female Figure

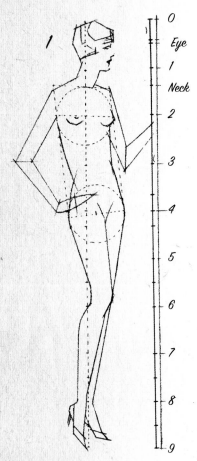

1

0
Eye
1
Neck
2
3
4
5
6
7
8
9

Draw a vertical line; then divide it into 8 heads numbered 2, 4, 6, and 8. Divide the second head into thirds. Two-thirds will give you the neckline.

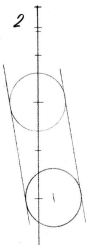

2

Place the point of a compass on 2 and extend it to the neckline. This will give you the size of the circle. Make the circles larger or smaller, depending on the desired physique.

3

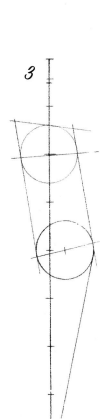

The hip goes up and the shoulder down on the side the figure is standing on, so draw the lines as shown at left. Next, draw the outer leg line, which gives you the swing of the figure.

4

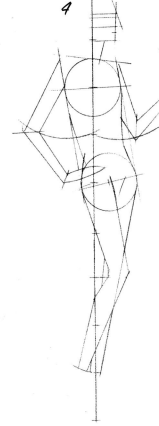

Draw lines for the body and add the arms. Note the elbows are at 3 heads, the knees are at 6 heads, and the ankles are at 8 heads. Sketch in the front line of the neck before extending the eyebrow and chin line.

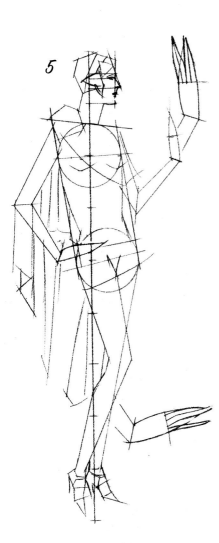

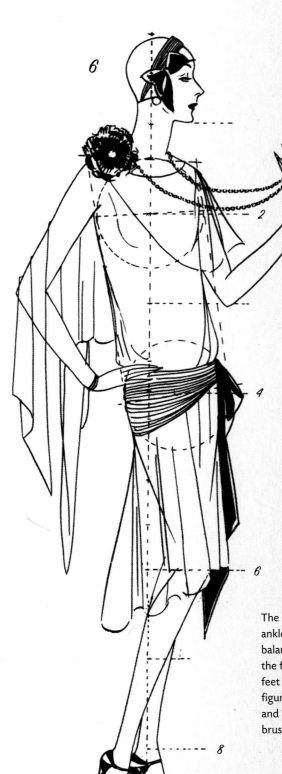

Finally, draw in leaf shapes for the hands. (See "Hands & Feet," page 28.) Dividing them down the middle gives you the length of fingers, but do not draw in the fingers until they are in the position you want them. Sketch in the garment.

The center of the neck and ankle are always on the line of balance (or vertical line) unless the figure is standing on both feet or in action. I made this figure with a No. 170 pen point and added black with a No. 3 brush.

The Urban Sophisticate

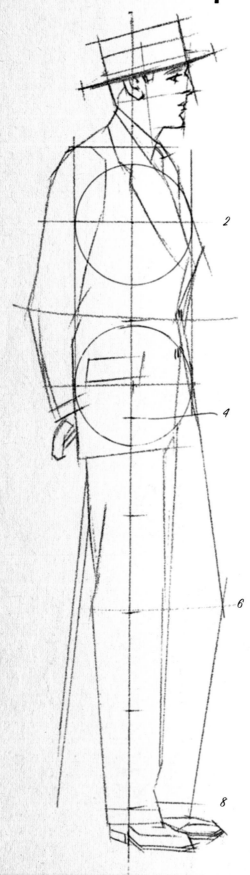

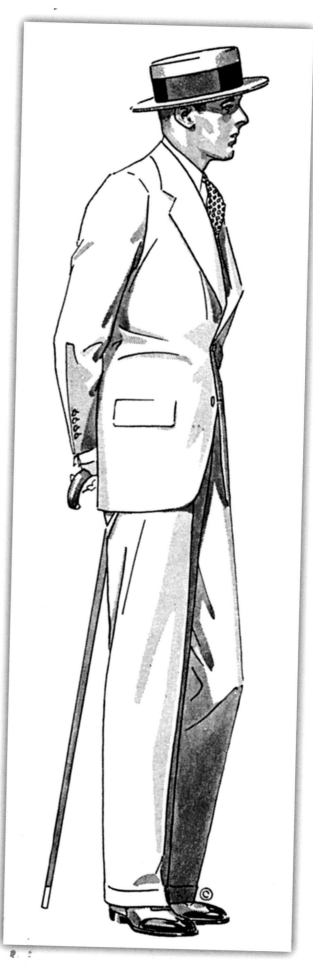

The circles are smaller when drawing the side view of a figure.
Place a compass on the chin line and extend it to the eyebrow
to get half the diameter of the circle.

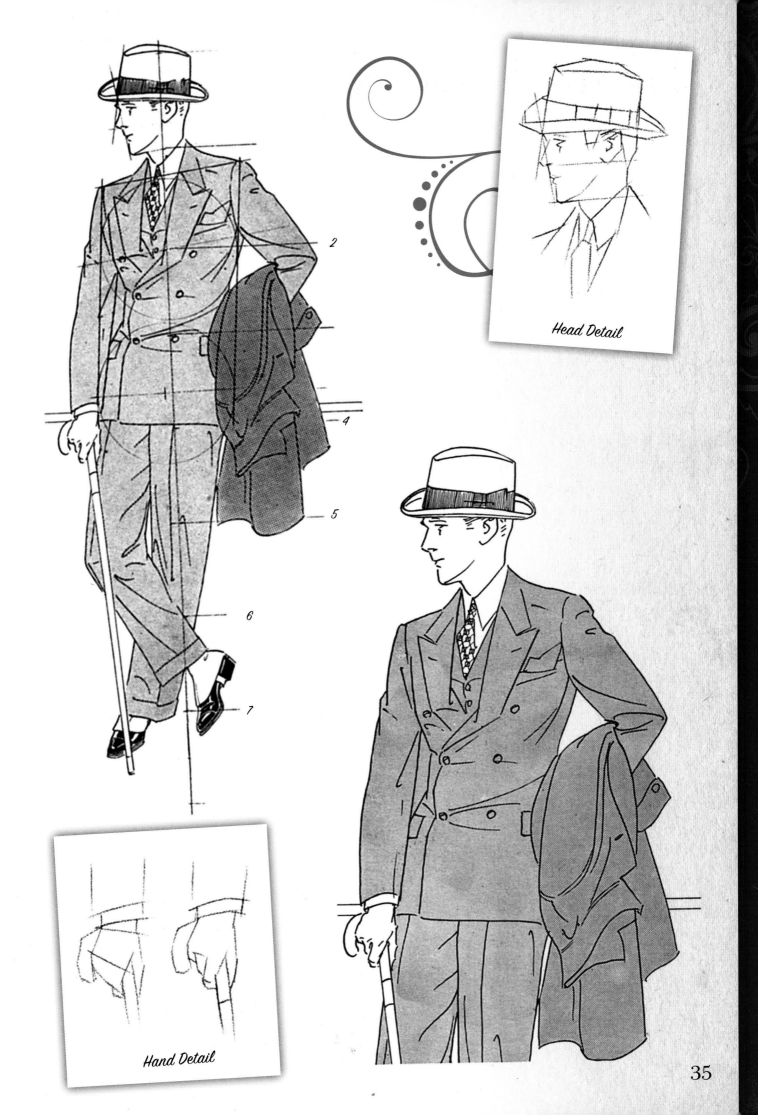

Head Detail

Hand Detail

2

4

5

6

7

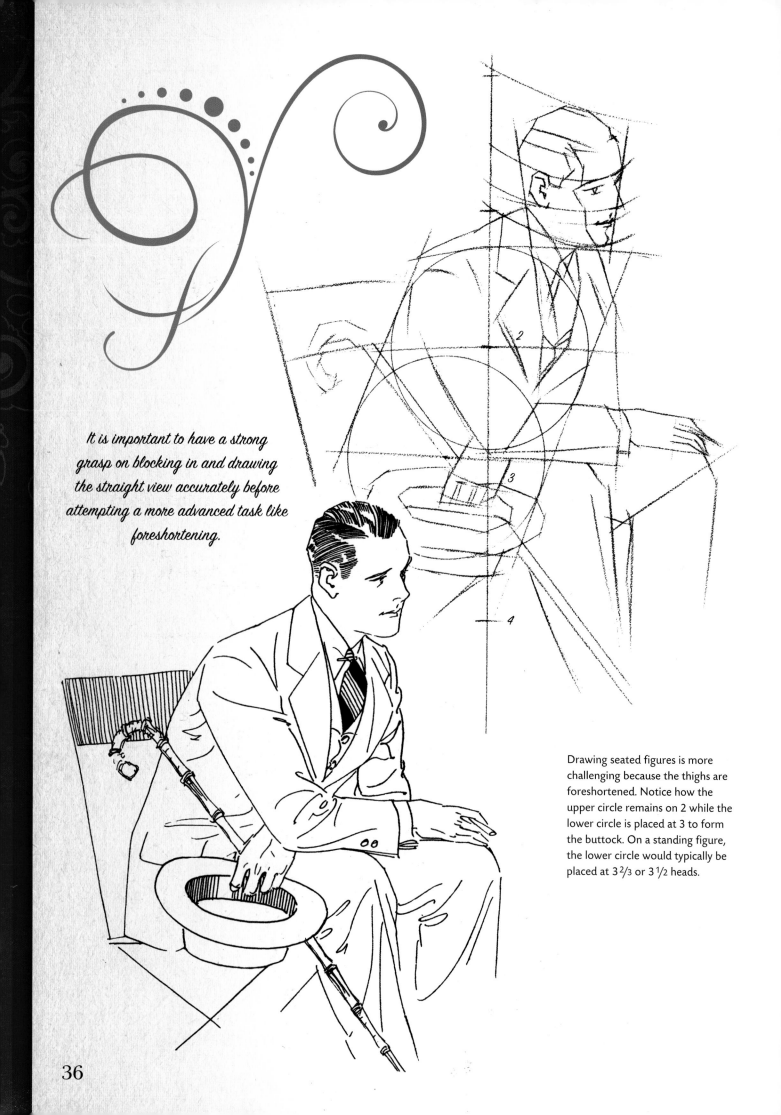

It is important to have a strong grasp on blocking in and drawing the straight view accurately before attempting a more advanced task like foreshortening.

Drawing seated figures is more challenging because the thighs are foreshortened. Notice how the upper circle remains on 2 while the lower circle is placed at 3 to form the buttock. On a standing figure, the lower circle would typically be placed at $3\frac{2}{3}$ or $3\frac{1}{2}$ heads.

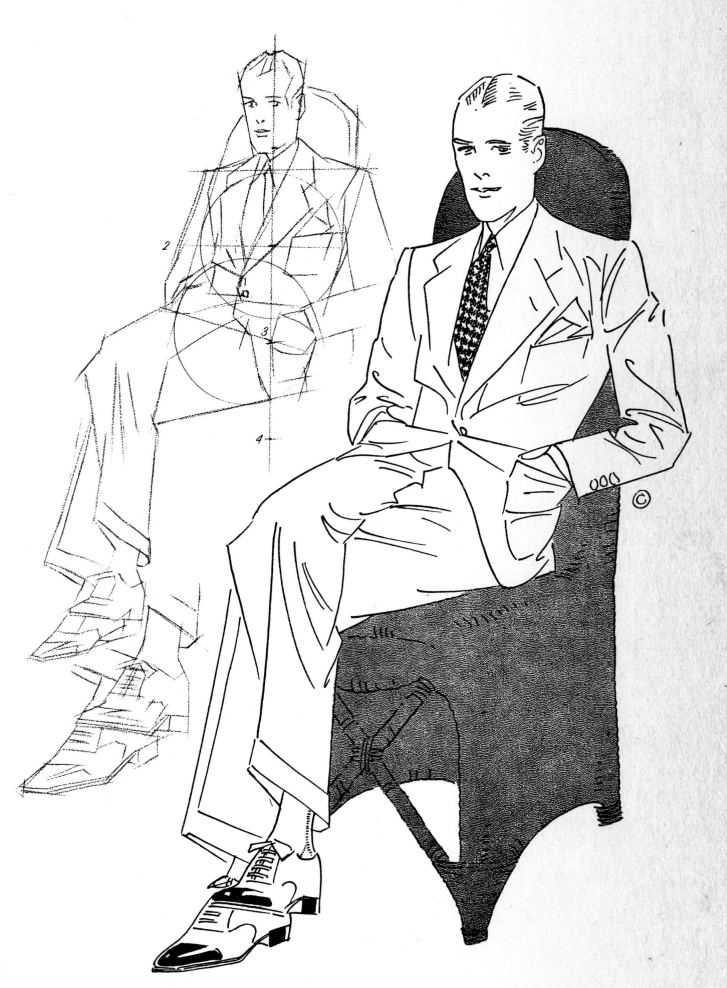

The Modern Woman

As in the drawing of the first Urban Sophisticate look on page 34, circles here also need to be smaller when sketching the side view. Begin by placing a compass on the chin line and extending it to the eyebrow to get half the diameter of the circle.

In an era when dresses were simple and skimmed the body to achieve the perfect blend of youth and elegance, accessories were key. Stoles, capes, necklaces, and earrings could turn an otherwise understated dress into an exquisite ensemble. Adorning the head with bejeweled headbands or combs, turbans, and cloche hats was another way to set oneself apart. The illustration below features the silent film-inspired skullcap.

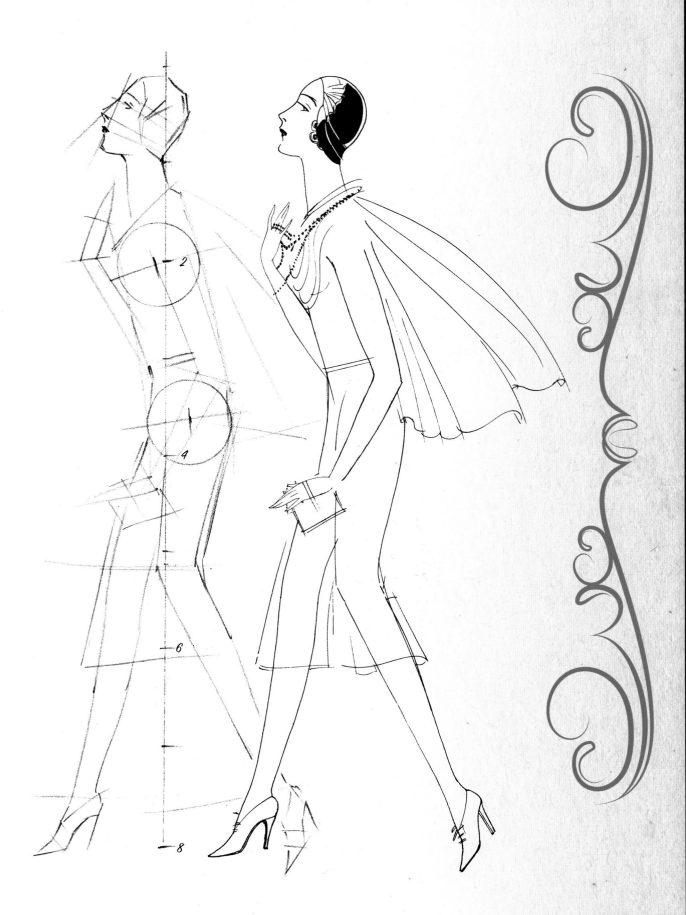

Keep in mind that as the decades evolve, so do proportions. A useful option is to choose the figure you like best and apply its proportions to all other figures.

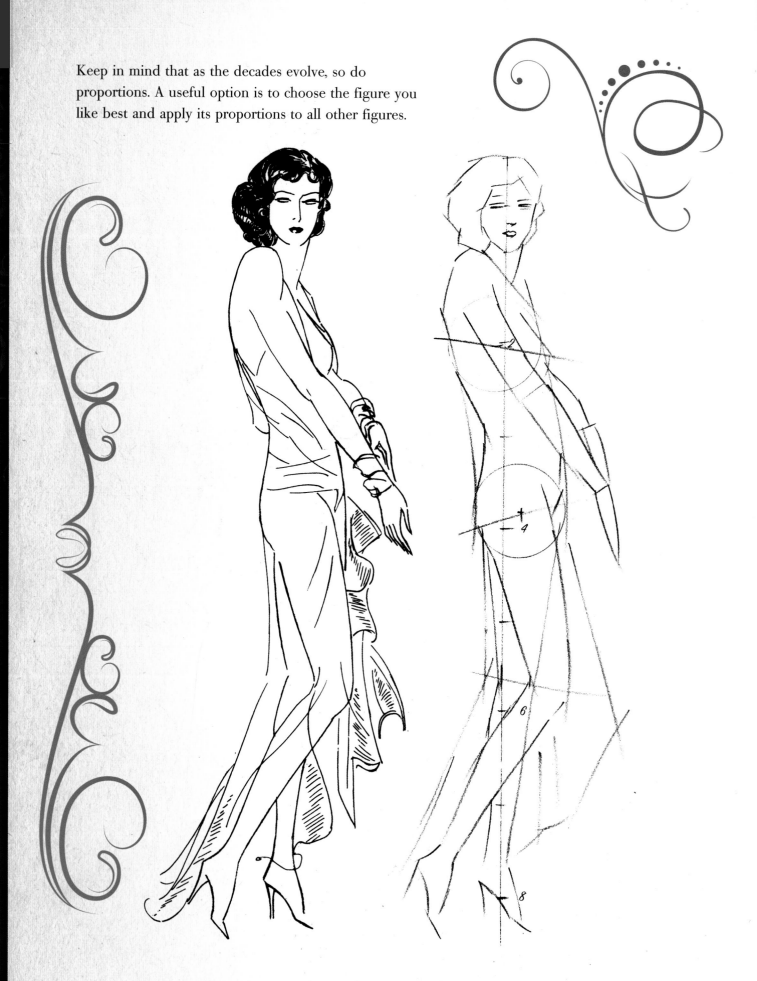

Remember not to draw in fingers until the position of the hands is certain. Scan magazine images or try posing in front of a mirror to find natural-looking positions.

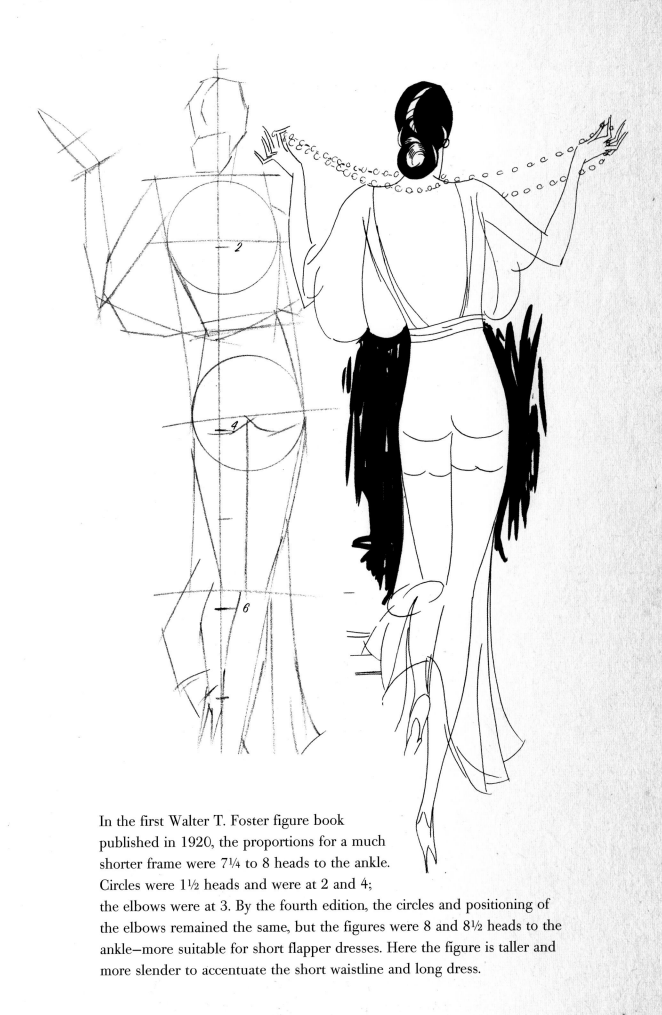

In the first Walter T. Foster figure book
published in 1920, the proportions for a much
shorter frame were 7¼ to 8 heads to the ankle.
Circles were 1½ heads and were at 2 and 4;
the elbows were at 3. By the fourth edition, the circles and positioning of
the elbows remained the same, but the figures were 8 and 8½ heads to the
ankle—more suitable for short flapper dresses. Here the figure is taller and
more slender to accentuate the short waistline and long dress.

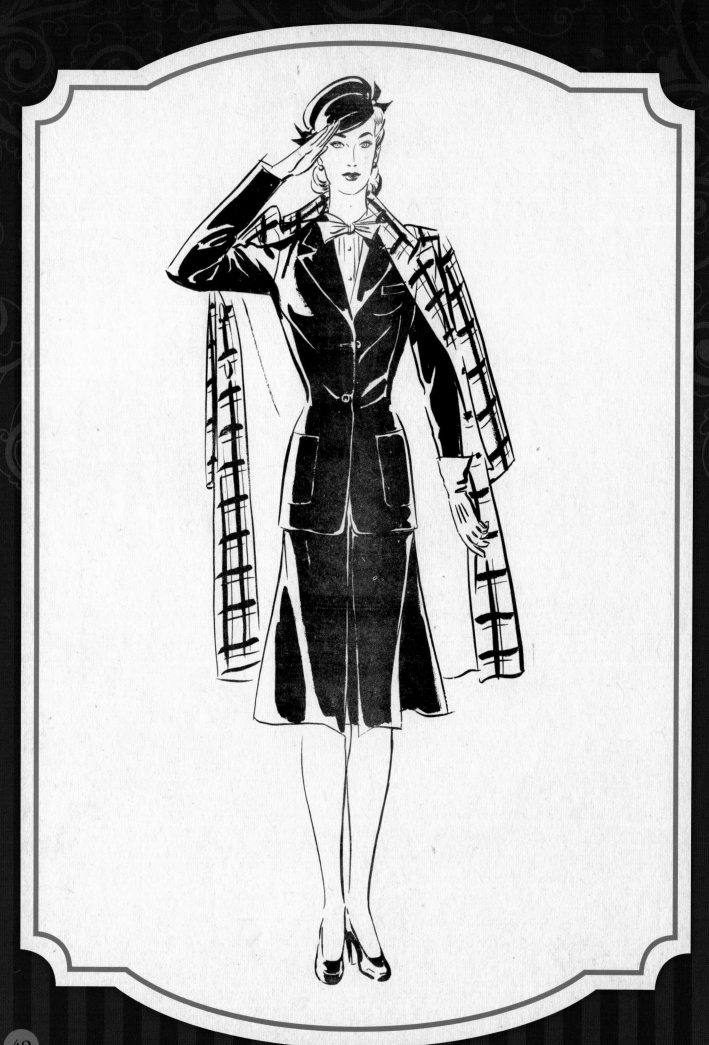

Chapter 3:
1940s
Female Fashions
with Walter T. Foster

Materials for constructing garments during the Second World War were restricted, but style certainly didn't suffer for it. Instead of nylon and wool, which were both rationed to help the war effort, rayon continued to thrive, as did denim, jersey, and wool blends. Fabric restrictions also meant that the cut of women's dresses and skirts had to change. Hemlines went up to the knee and dresses were cut narrower, skimming the body in a fresh and flattering way. Trousers hit the scene, too, not only because so many women worked in factories, but because film siren Katharine Hepburn made the look appear effortlessly sexy. Even shorts found their way into the limelight, serving as a playful alternative to the somewhat militaristic feel of broad suit jackets and slim skirts. Needless to say, the 1940s woman was nothing if not resourceful. To conserve cash, women began wearing their hair longer than in previous decades and tanned their legs with makeup to achieve the appearance of nylons.

The Bombshell

When drawing clothing, it must look like it covers a real body. Taking a life drawing class and making dozens of quick sketches of various body parts is an excellent way to gain an understanding of the anatomy.

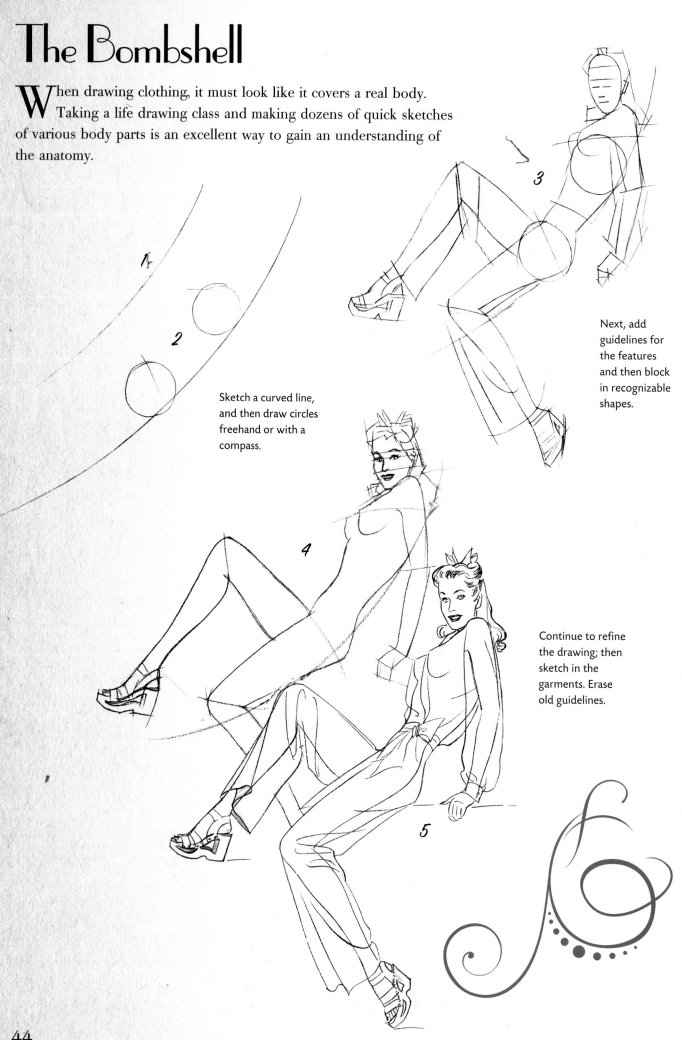

Sketch a curved line, and then draw circles freehand or with a compass.

Next, add guidelines for the features and then block in recognizable shapes.

Continue to refine the drawing; then sketch in the garments. Erase old guidelines.

44

The Siren

It is essential to practice drawing the figure in all positions. Again, remember to think about what you intend to do first. A few well-chosen pencil strokes are less confusing than scratchy lines.

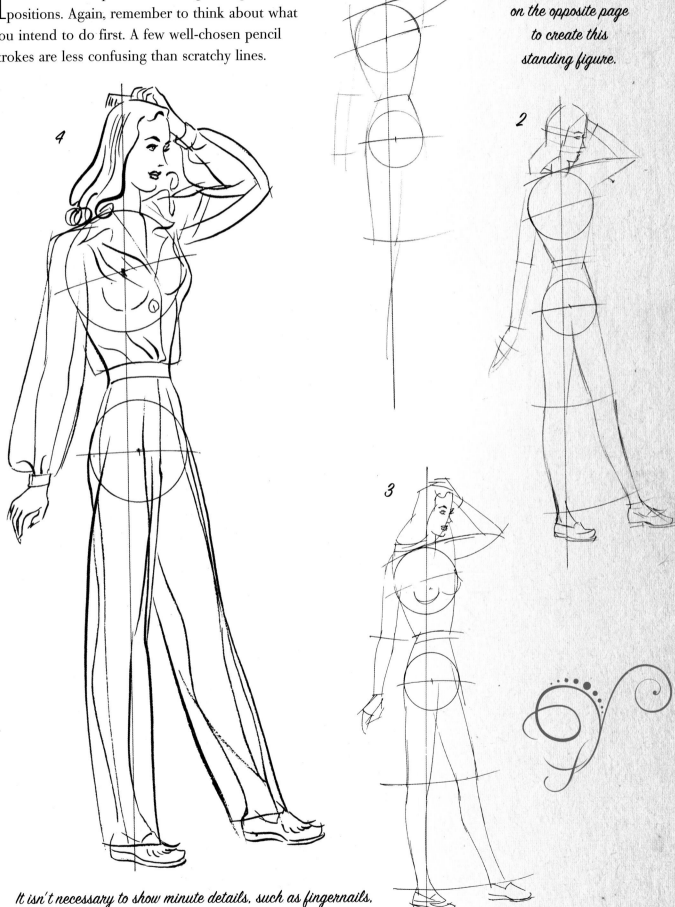

Follow the directions on the opposite page to create this standing figure.

It isn't necessary to show minute details, such as fingernails, on small figures.

Ladies of Leisure

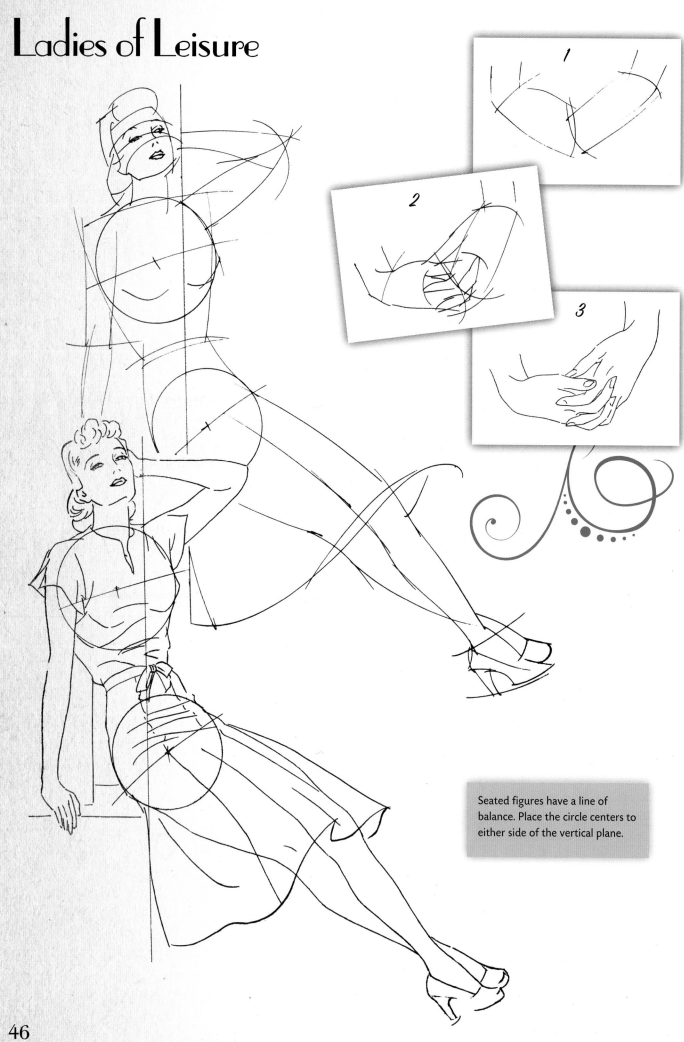

Seated figures have a line of balance. Place the circle centers to either side of the vertical plane.

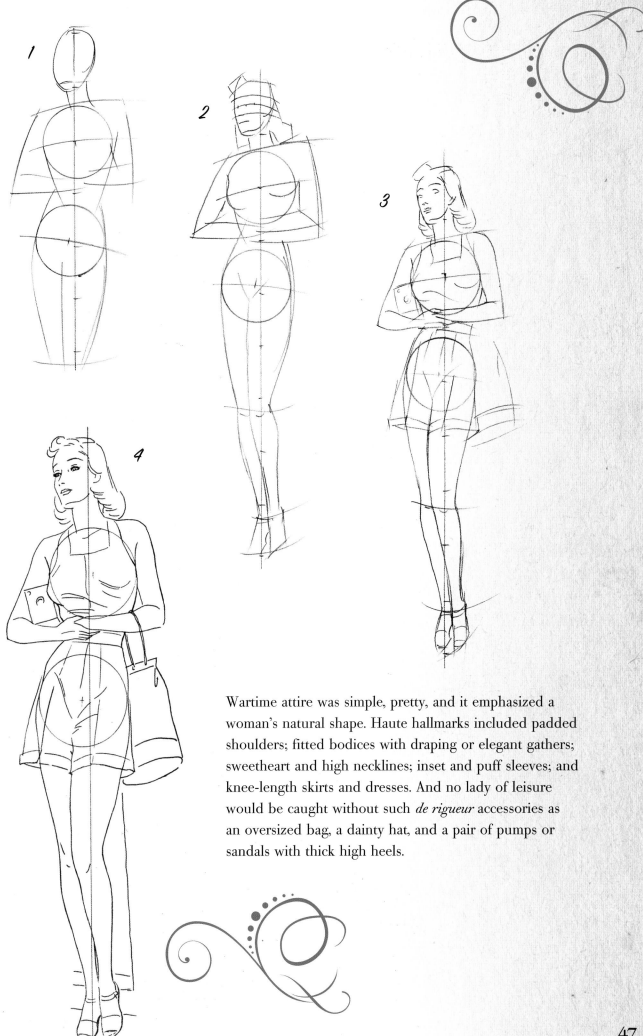

Wartime attire was simple, pretty, and it emphasized a woman's natural shape. Haute hallmarks included padded shoulders; fitted bodices with draping or elegant gathers; sweetheart and high necklines; inset and puff sleeves; and knee-length skirts and dresses. And no lady of leisure would be caught without such *de rigueur* accessories as an oversized bag, a dainty hat, and a pair of pumps or sandals with thick high heels.

The Professional

1

2

2

4

6

8

At this point,
strive to keep your
drawing simple.

Your primary objective should be to give the figure a nice, graceful swing. Notice the way the sides of the coat and its left sleeve suggest movement. The skirt, too, appears to move with the bent knee.

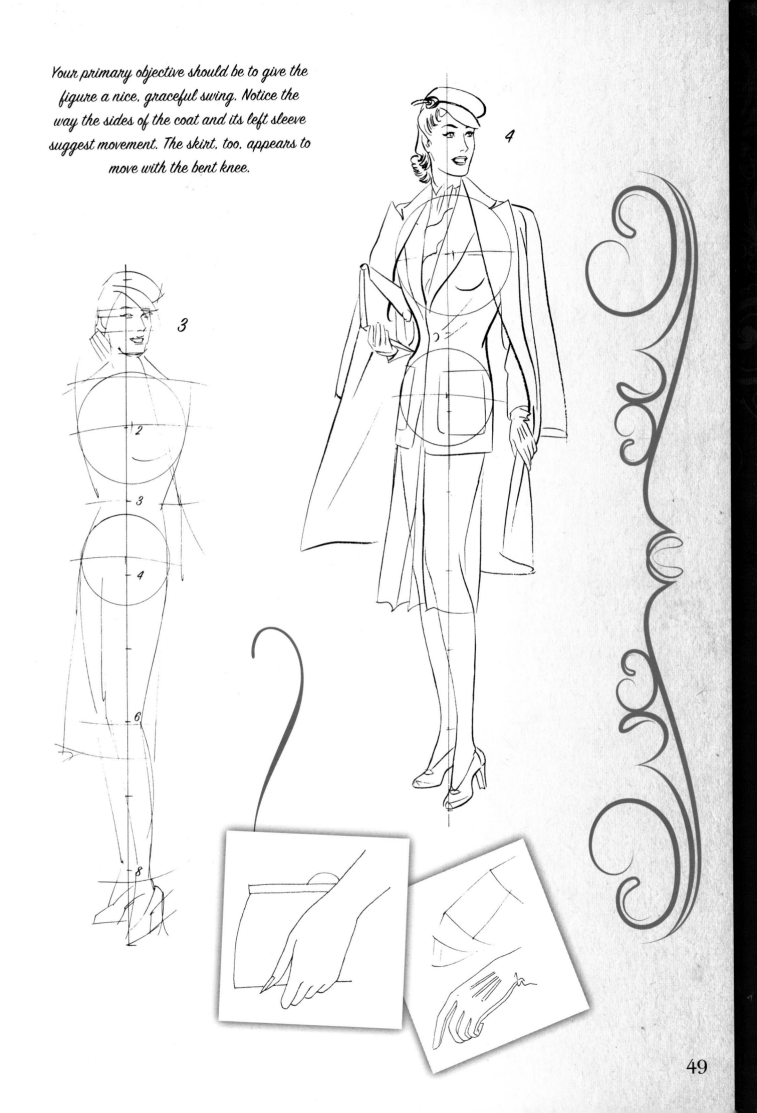

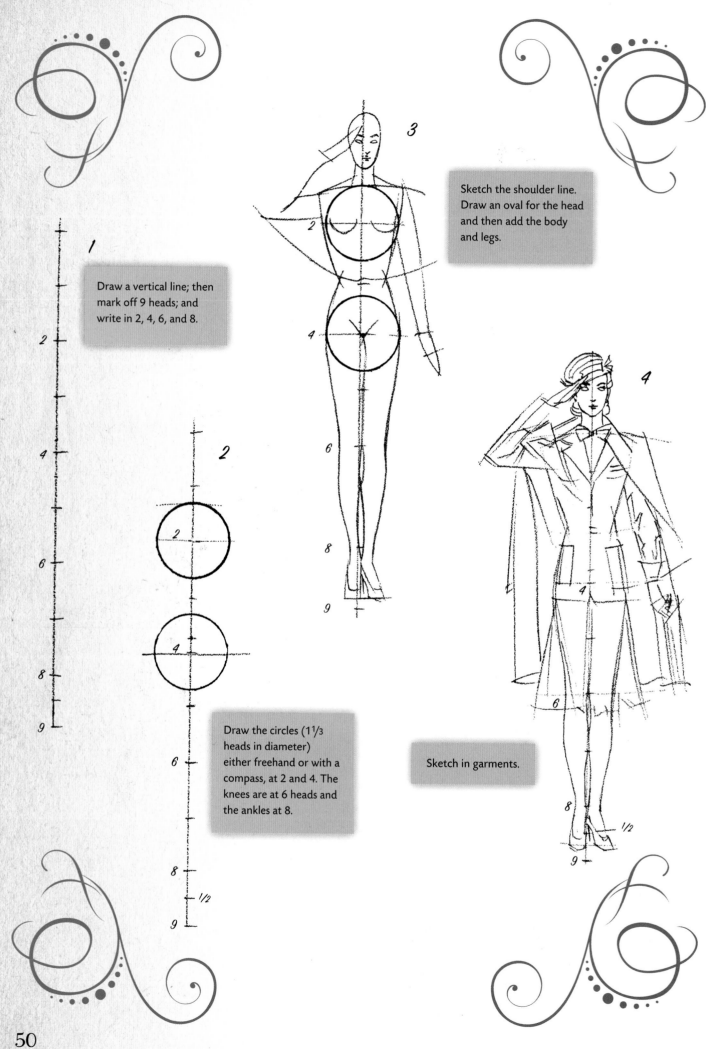

1

Draw a vertical line; then mark off 9 heads; and write in 2, 4, 6, and 8.

2

Draw the circles (1⅓ heads in diameter) either freehand or with a compass, at 2 and 4. The knees are at 6 heads and the ankles at 8.

3

Sketch the shoulder line. Draw an oval for the head and then add the body and legs.

4

Sketch in garments.

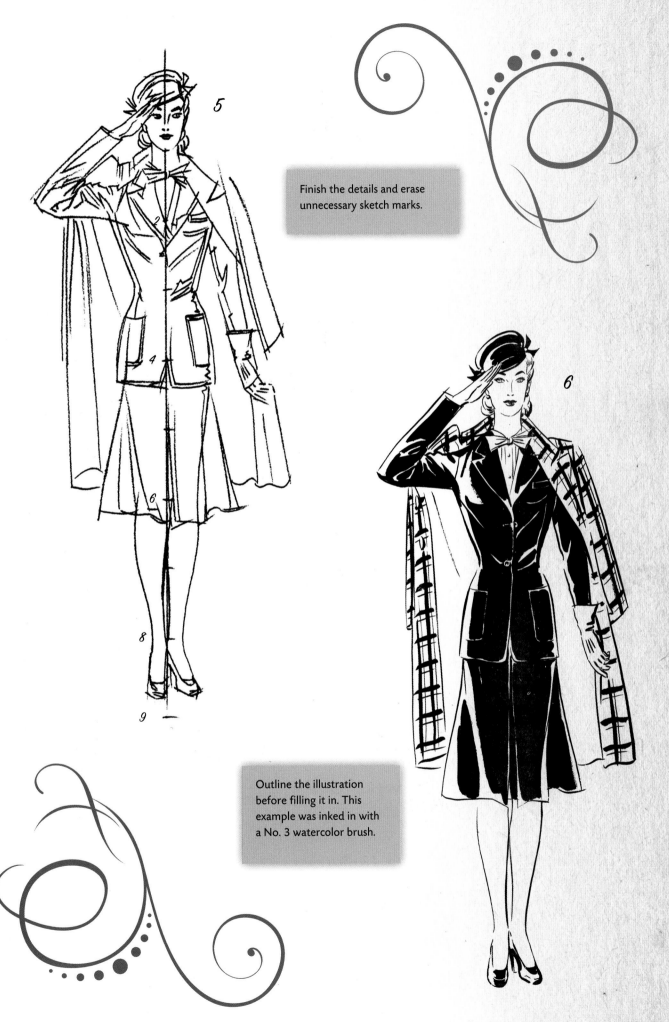

Finish the details and erase unnecessary sketch marks.

Outline the illustration before filling it in. This example was inked in with a No. 3 watercolor brush.

The Starlet

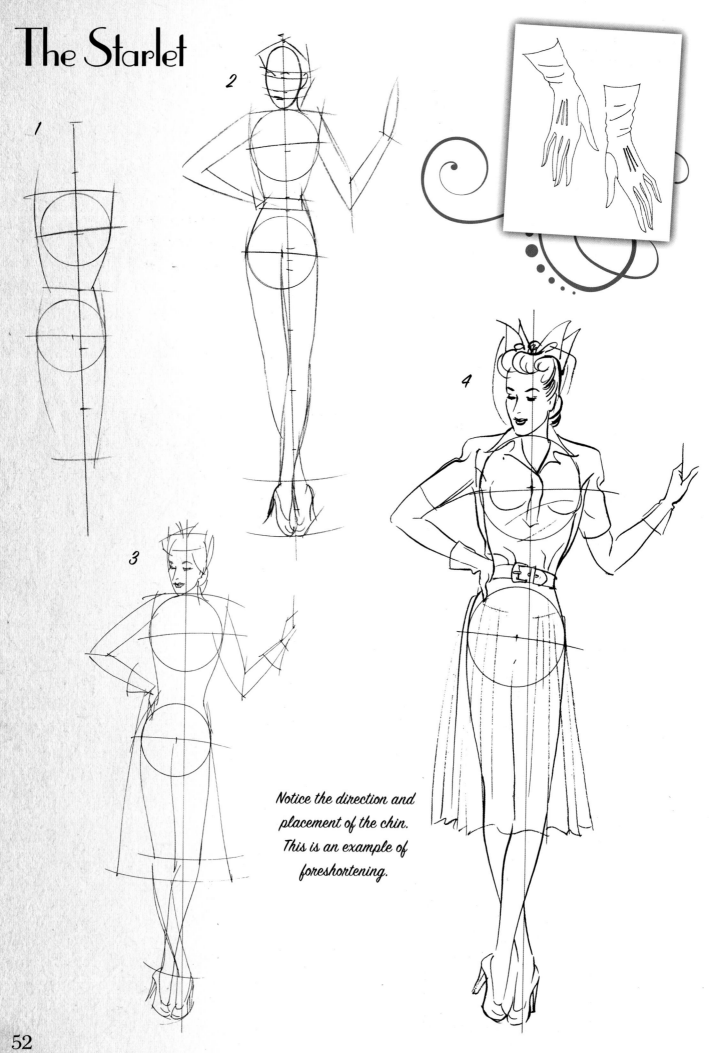

1

2

3

4

Notice the direction and placement of the chin. This is an example of foreshortening.

The Icon

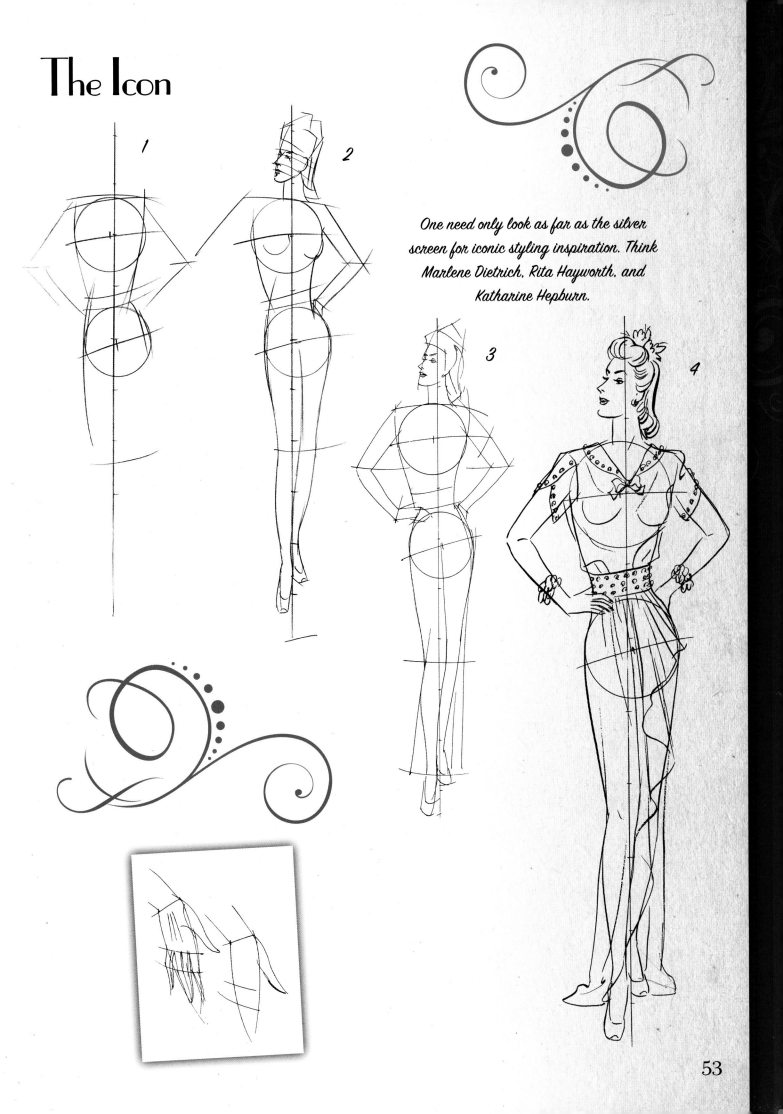

1

2

3

4

One need only look as far as the silver screen for iconic styling inspiration. Think Marlene Dietrich, Rita Hayworth, and Katharine Hepburn.

Beauty in Motion

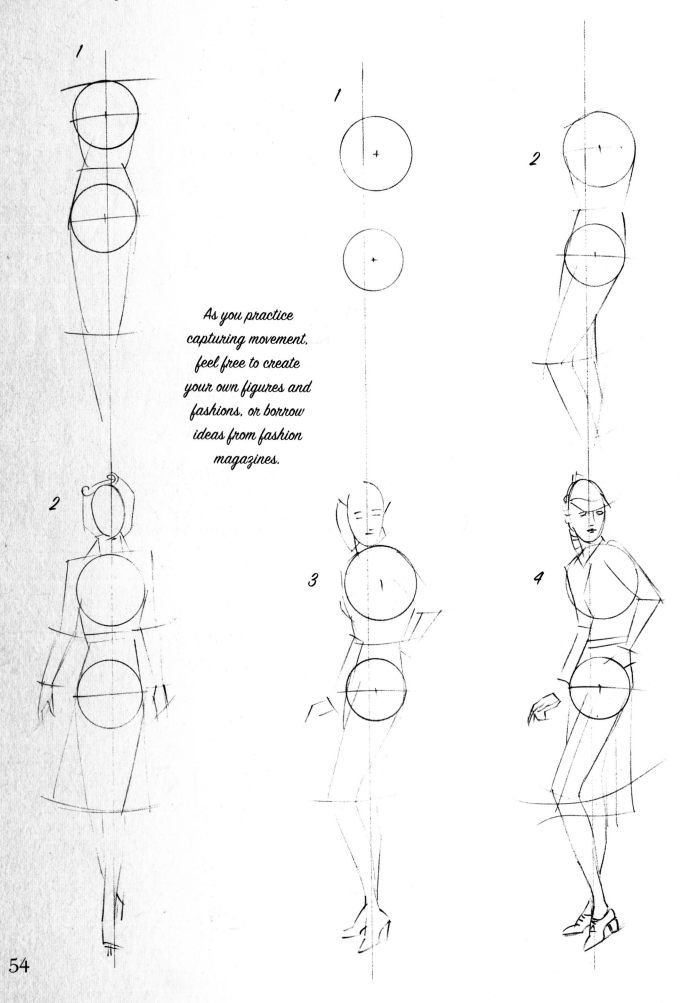

As you practice capturing movement, feel free to create your own figures and fashions, or borrow ideas from fashion magazines.

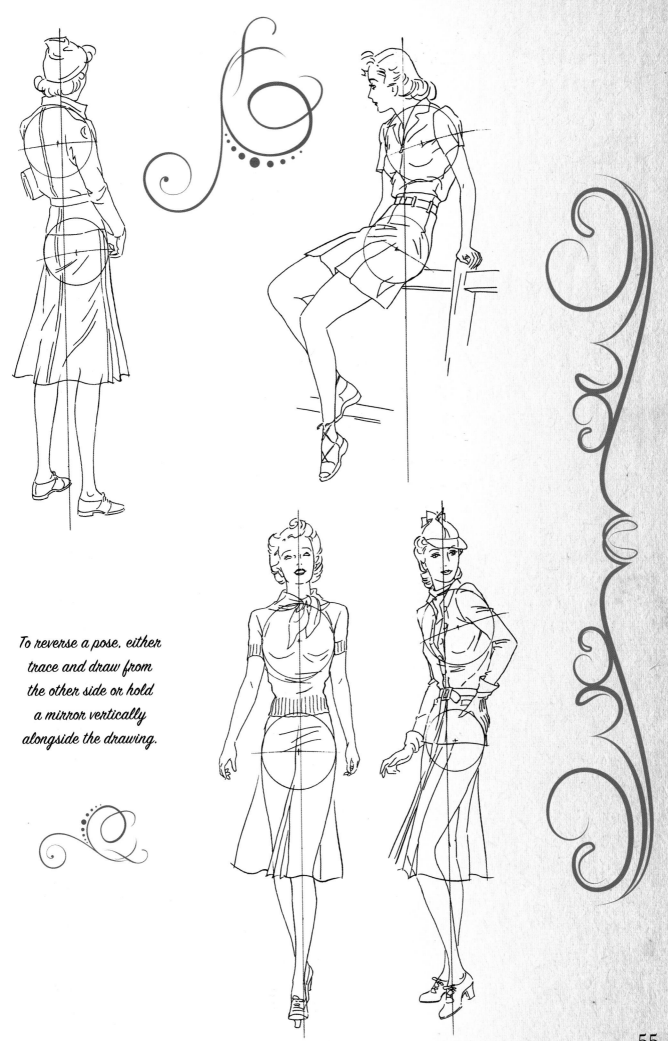

To reverse a pose, either
trace and draw from
the other side or hold
a mirror vertically
alongside the drawing.

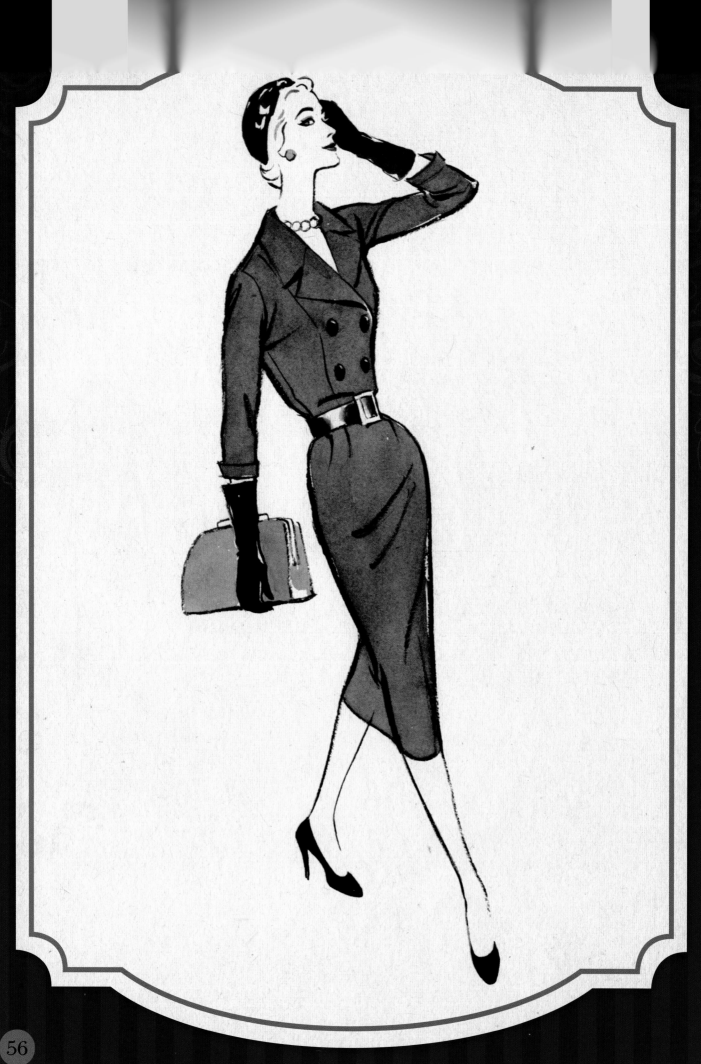

Chapter 4:
1950s
Female Fashions
with Viola French

Christian Dior's New Look, which revolutionized high fashion and sent military style packing in 1947, continued into the early 1950s. However, Dior had a sleeker silhouette in mind for fashion-conscious women. In 1954, he launched the H-line, which featured a form-fitting pencil skirt falling just below the knee and a slim-cut jacket meant to be accessorized with demure gloves and the perfect hat. The following year, he introduced the Y-line, still with a slim skirt, but with a wider neckline and exaggerated shoulders. His influence was so great that other fashion houses had no choice but to follow his lead. "Pretty" became the buzzword for womenswear, and any garment that enhanced a woman's femininity became a hot commodity. Corsets and corset-bra sets were hailed as revolutionary undergarments, as was the conical bra, which gave a woman an enviable figure, although admittedly not a natural-looking one.

The Face of Fashion

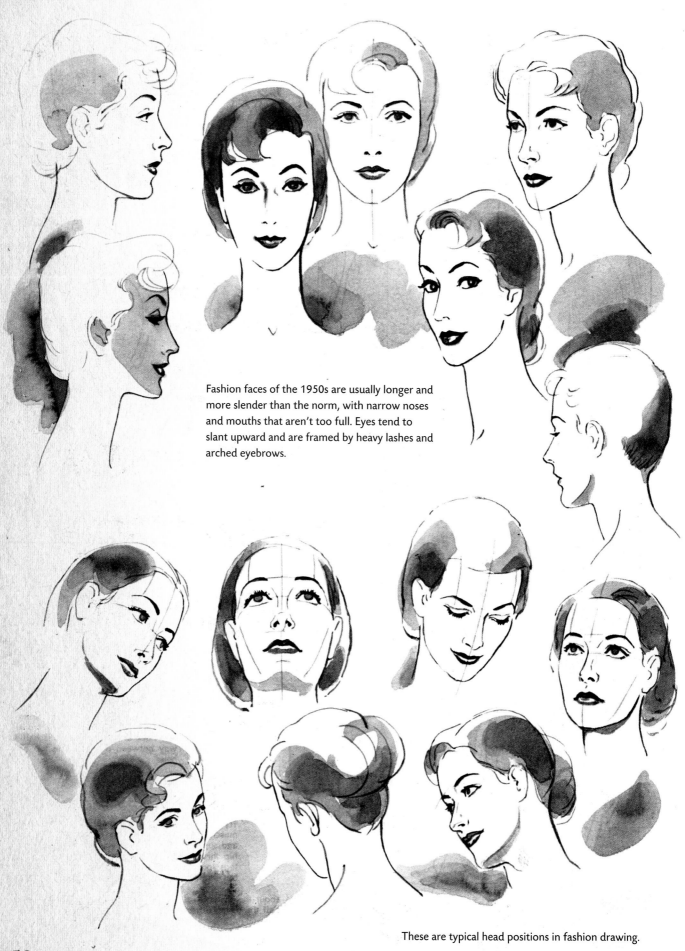

Fashion faces of the 1950s are usually longer and more slender than the norm, with narrow noses and mouths that aren't too full. Eyes tend to slant upward and are framed by heavy lashes and arched eyebrows.

These are typical head positions in fashion drawing.

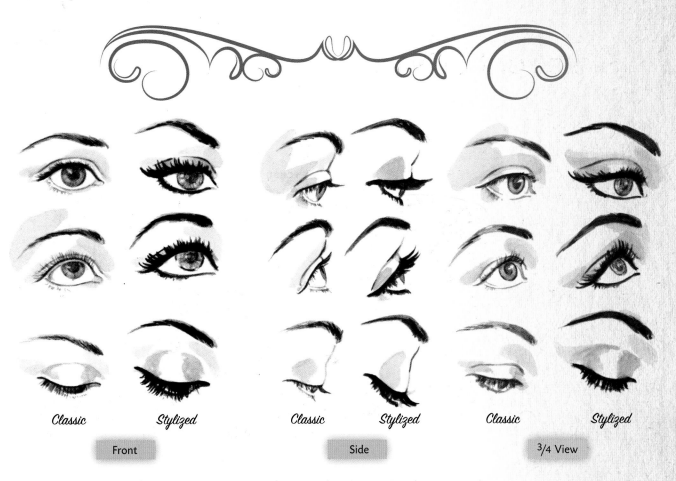

Classic Stylized Classic Stylized Classic Stylized

Front Side 3/4 View

Try to capture exotic beauty, charm, and sophistication in your facial features.

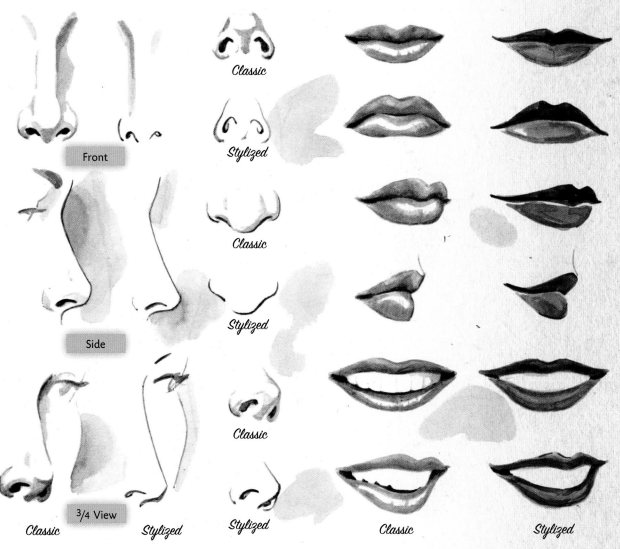

Front

Classic

Stylized

Side

Classic

Stylized

3/4 View

Classic Stylized Stylized Classic Stylized

59

Fashion Proportions

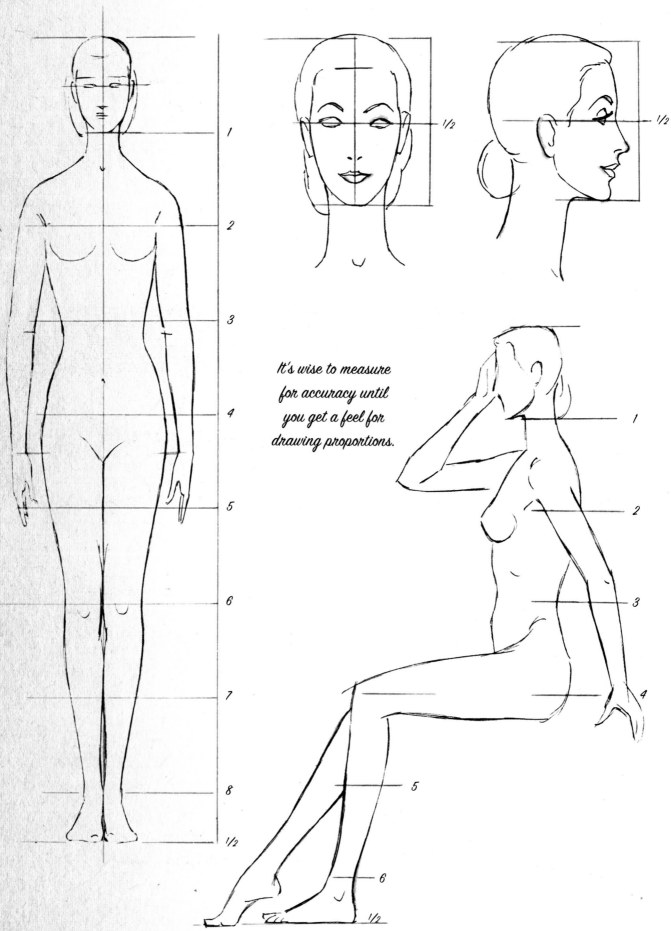

It's wise to measure for accuracy until you get a feel for drawing proportions.

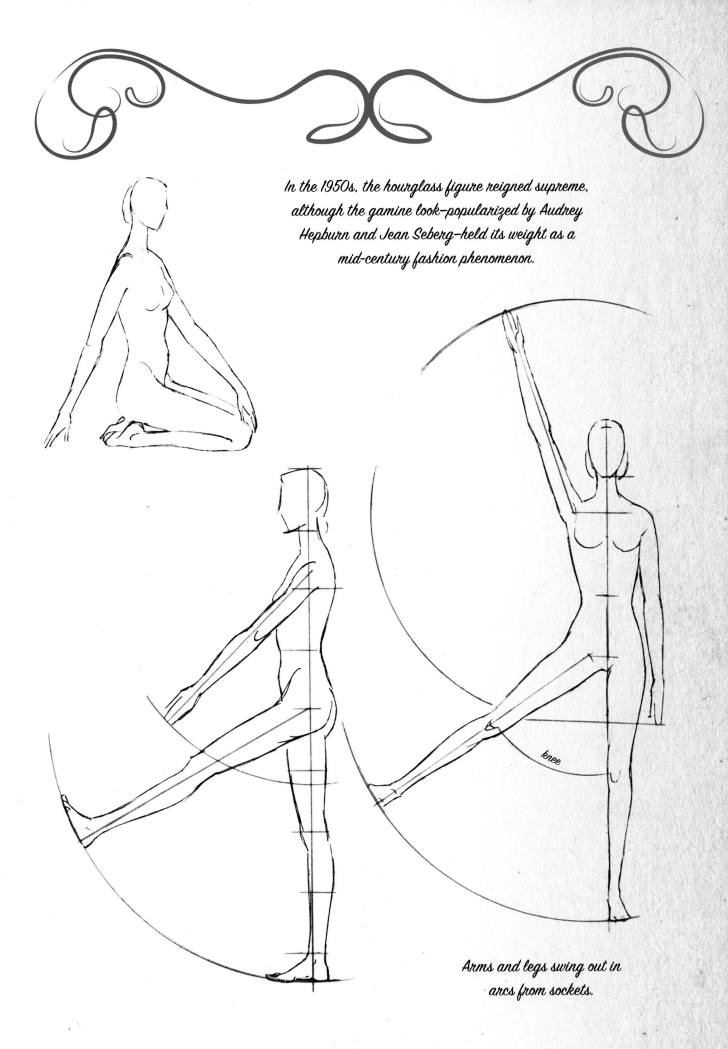

In the 1950s, the hourglass figure reigned supreme, although the gamine look—popularized by Audrey Hepburn and Jean Seberg—held its weight as a mid-century fashion phenomenon.

knee

Arms and legs swing out in arcs from sockets.

Roughing in the Figure

Study the shape of the space the figure is to occupy. The pose you choose should be one that best fits the space, but it also must show off the garment. Aim to create pleasing action and interesting arrangements, remembering that diagonal lines are useful for drawing attention. Use ovals to place the figure. When you're familiar with the proportions you can rough in the figure without them.

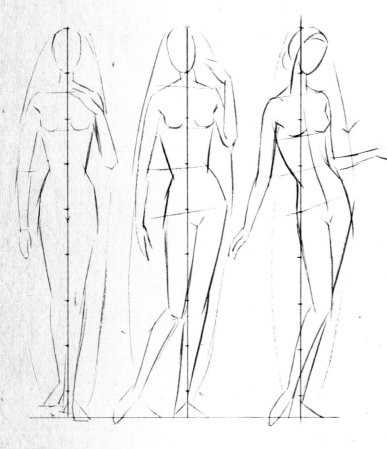

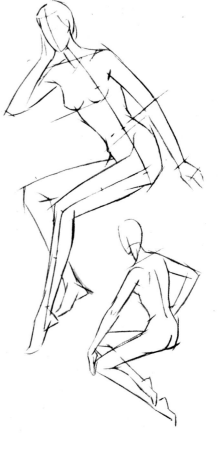

To communicate movement, curve your line of action, measuring each leg separately.

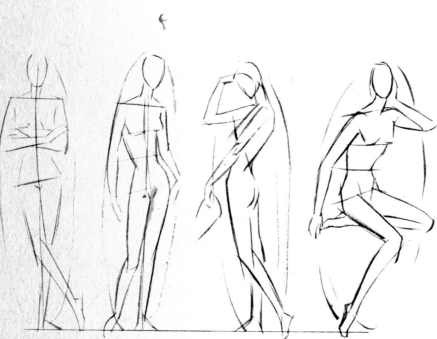

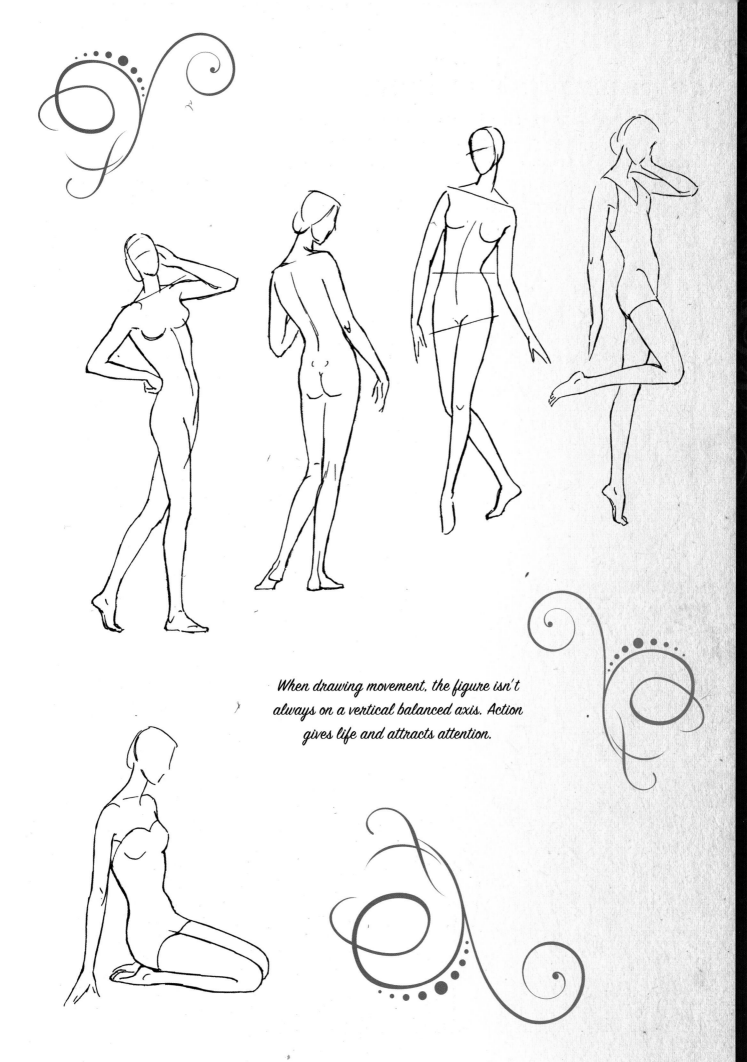

When drawing movement, the figure isn't
always on a vertical balanced axis. Action
gives life and attracts attention.

Sources to Draw From

If you're lucky enough to get a model or a friend who poses gracefully, your job will be easier. You may have to direct the position to achieve the desired effect. Another option is to stand in front of a long mirror. Get a feel for the pose and the way the fabric of your garment falls and creases. Be sure to simplify the basic lines and elongate. Try drawing a rough sketch in normal proportions before rendering it in fashion proportions. When you become more advanced, you will automatically draw your figures in a stylized way.

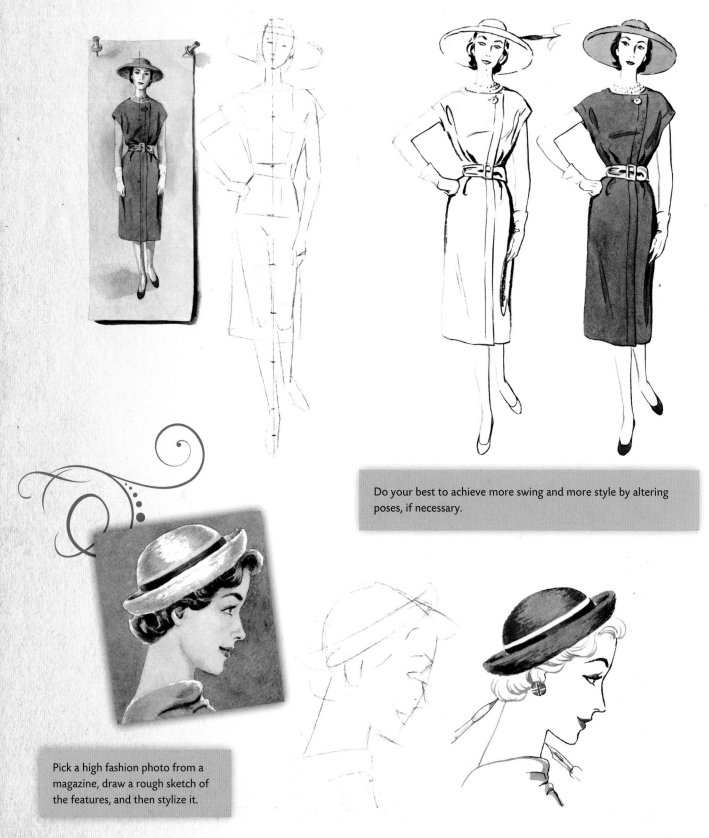

Do your best to achieve more swing and more style by altering poses, if necessary.

Pick a high fashion photo from a magazine, draw a rough sketch of the features, and then stylize it.

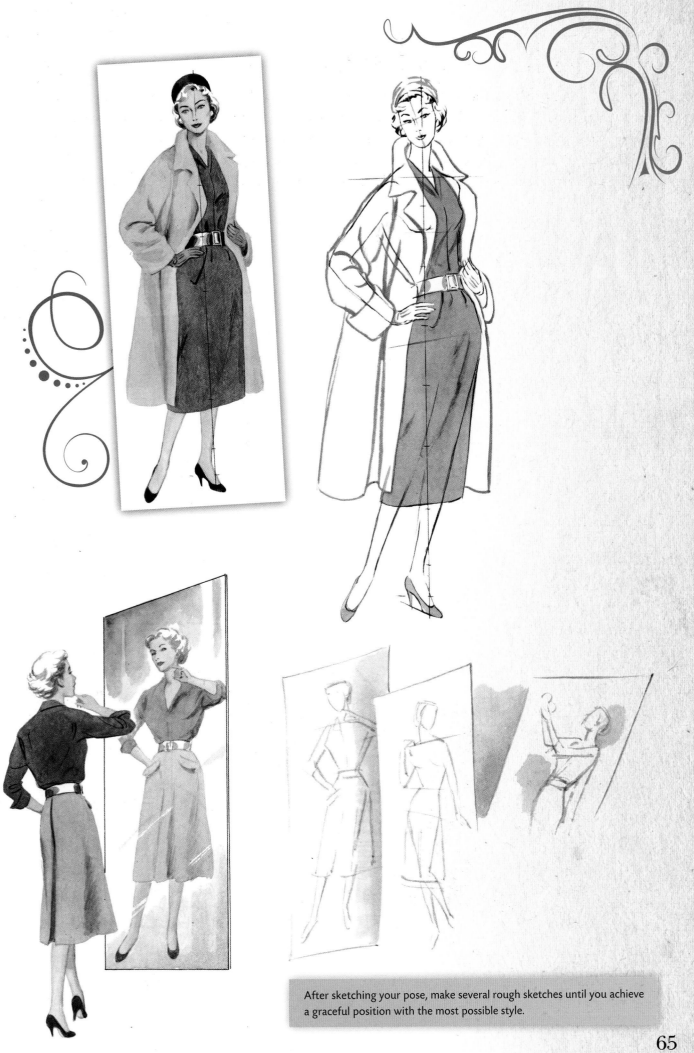

After sketching your pose, make several rough sketches until you achieve a graceful position with the most possible style.

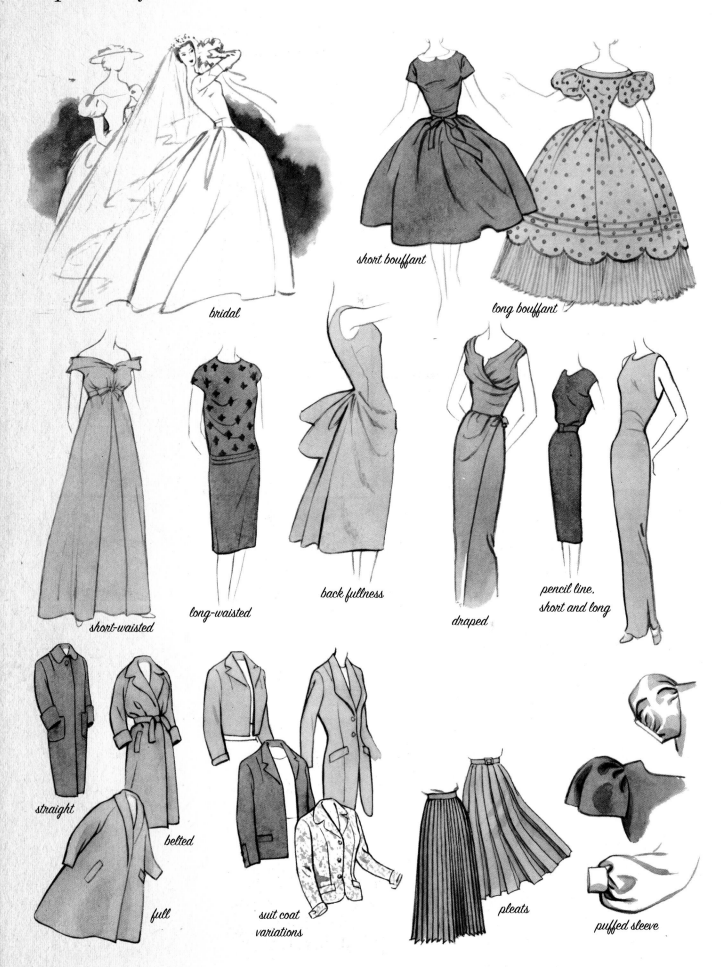

bridal

short bouffant

long bouffant

short-waisted

long-waisted

back fullness

draped

pencil line, short and long

straight

belted

full

suit coat variations

pleats

puffed sleeve

Folds & Patterns

Folds fall from an outstretched or high part of the body.
Material stands out from raised hip.

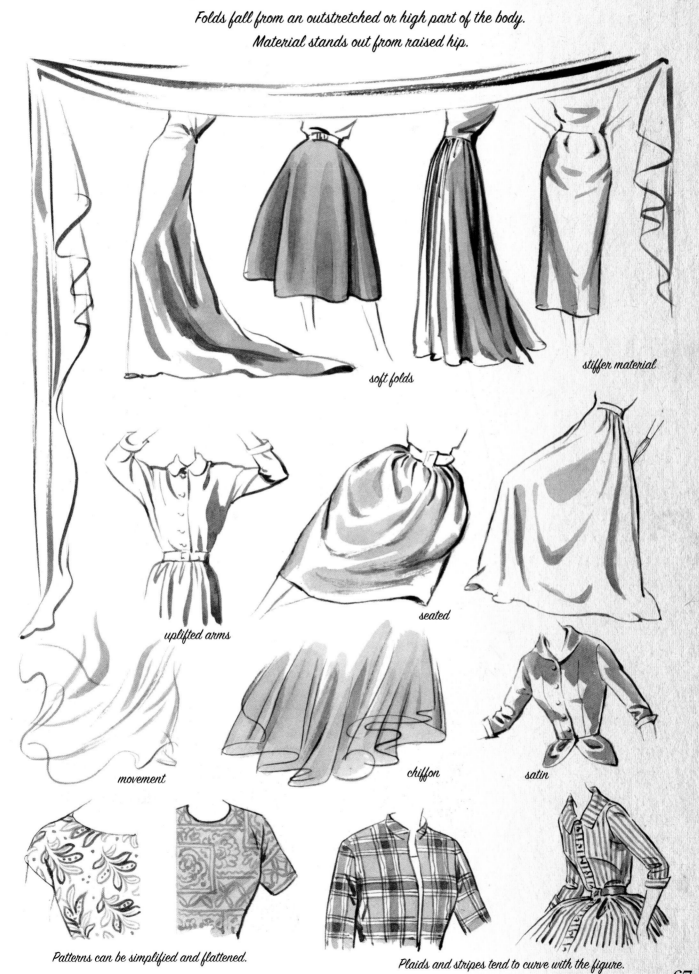

soft folds

stiffer material

uplifted arms

seated

movement

chiffon

satin

Patterns can be simplified and flattened.

Plaids and stripes tend to curve with the figure.

Rendering Fashions

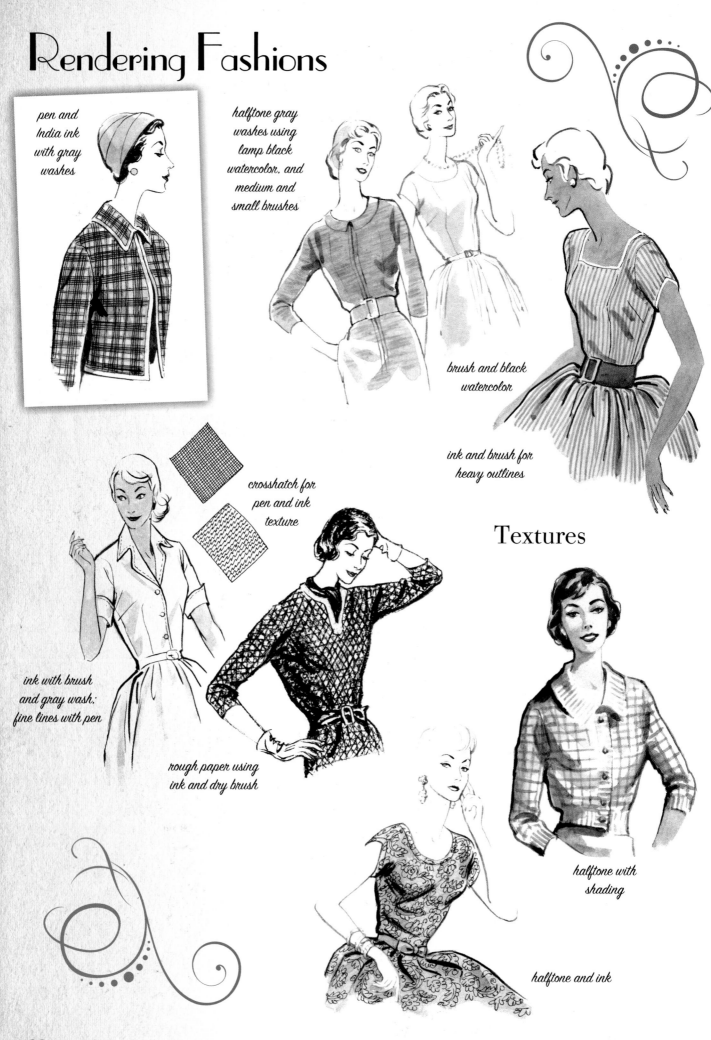

pen and India ink with gray washes

halftone gray washes using lamp black watercolor, and medium and small brushes

brush and black watercolor

ink and brush for heavy outlines

crosshatch for pen and ink texture

Textures

ink with brush and gray wash; fine lines with pen

rough paper using ink and dry brush

halftone with shading

halftone and ink

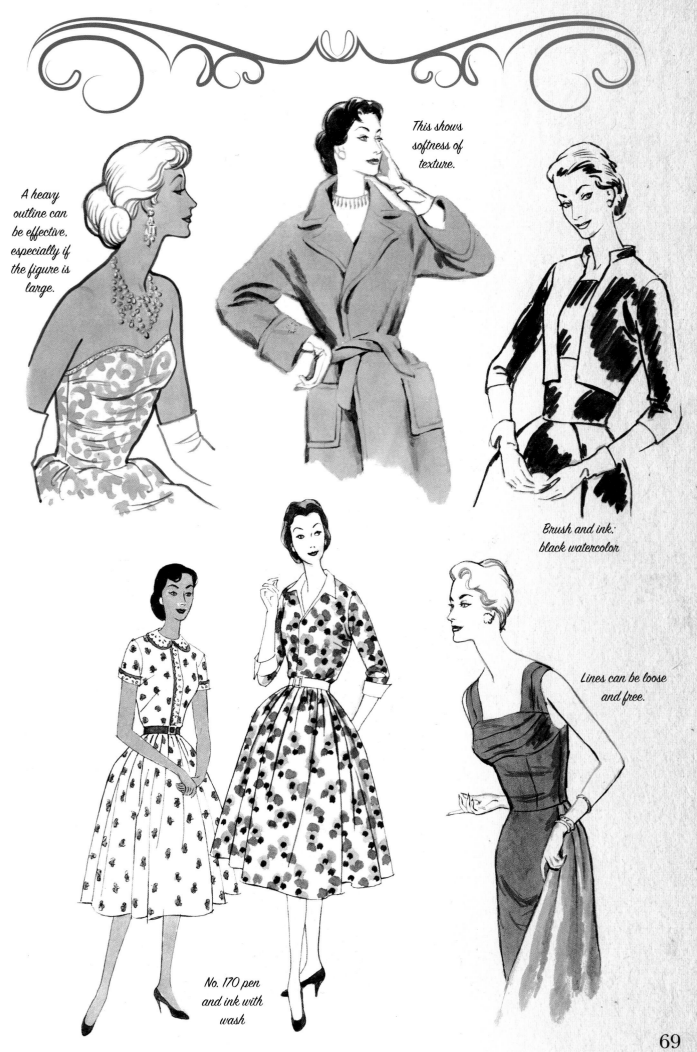

A heavy outline can be effective, especially if the figure is large.

This shows softness of texture.

Brush and ink: black watercolor

Lines can be loose and free.

No. 170 pen and ink with wash

69

Wool

Fur

Combination of brush. pen and ink.

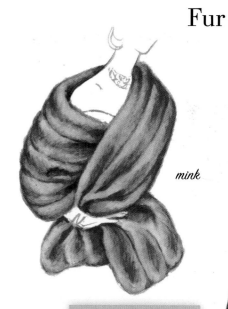

mink

For softness, work with paper slightly wet.

soft wool coat

crisp wool suit

broadtail

seal or beaver

jersey

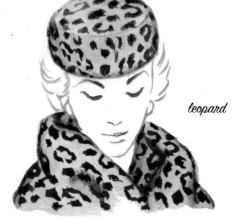

leopard

Millinery

Combination of brush with black watercolor, along with pen and ink.

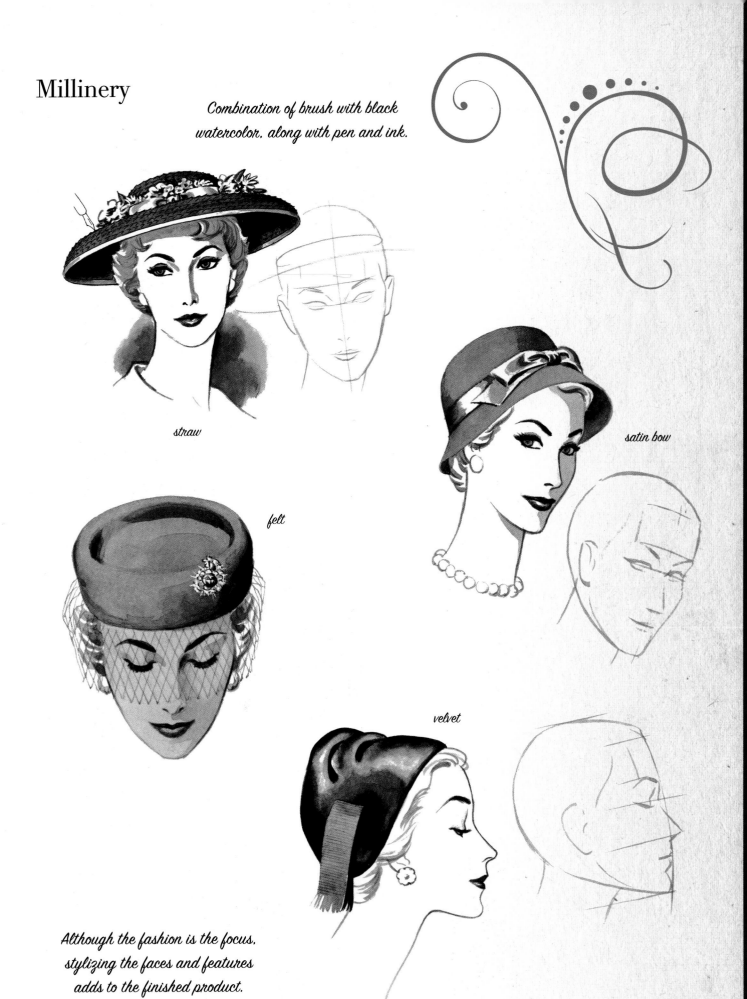

straw

felt

satin bow

velvet

Although the fashion is the focus, stylizing the faces and features adds to the finished product.

Lookbook: Daywear

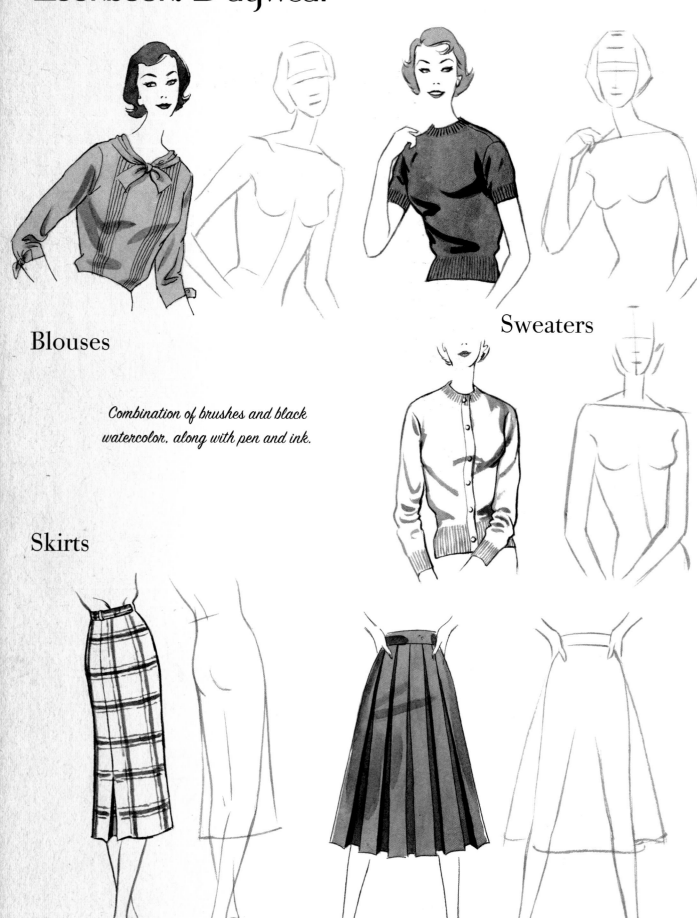

Blouses

Sweaters

Combination of brushes and black watercolor, along with pen and ink.

Skirts

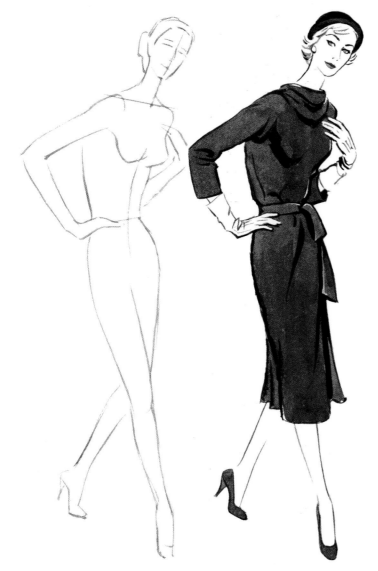

Street Dresses

Strive to draw a variety of poses, but don't forget to show the best features of the garment.

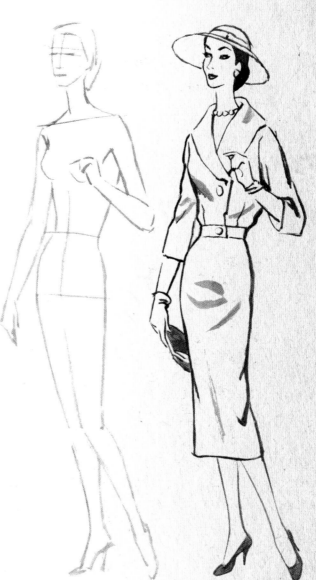

Combination of brushes and black watercolor, along with pen and ink.

Suits

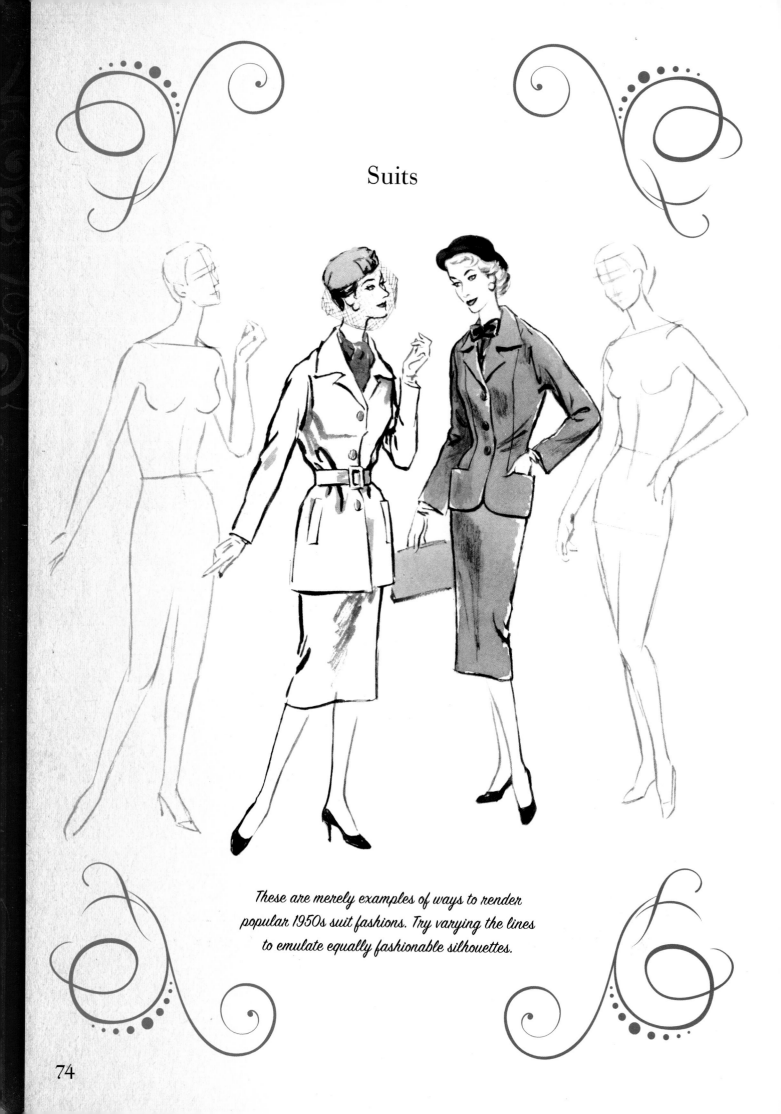

*These are merely examples of ways to render
popular 1950s suit fashions. Try varying the lines
to emulate equally fashionable silhouettes.*

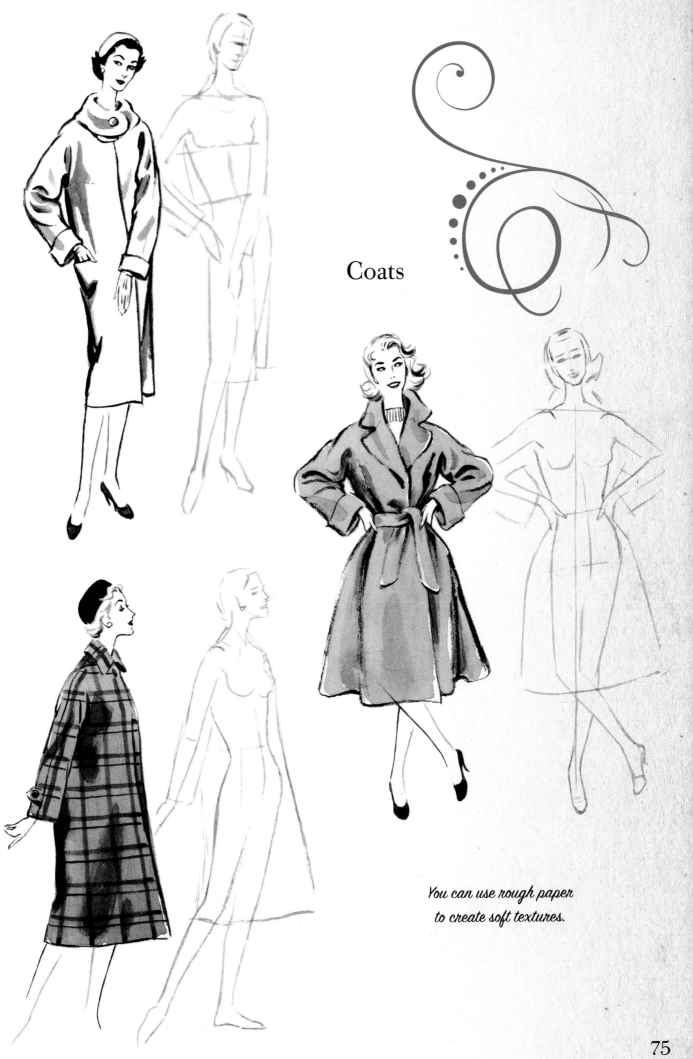

Coats

*You can use rough paper
to create soft textures.*

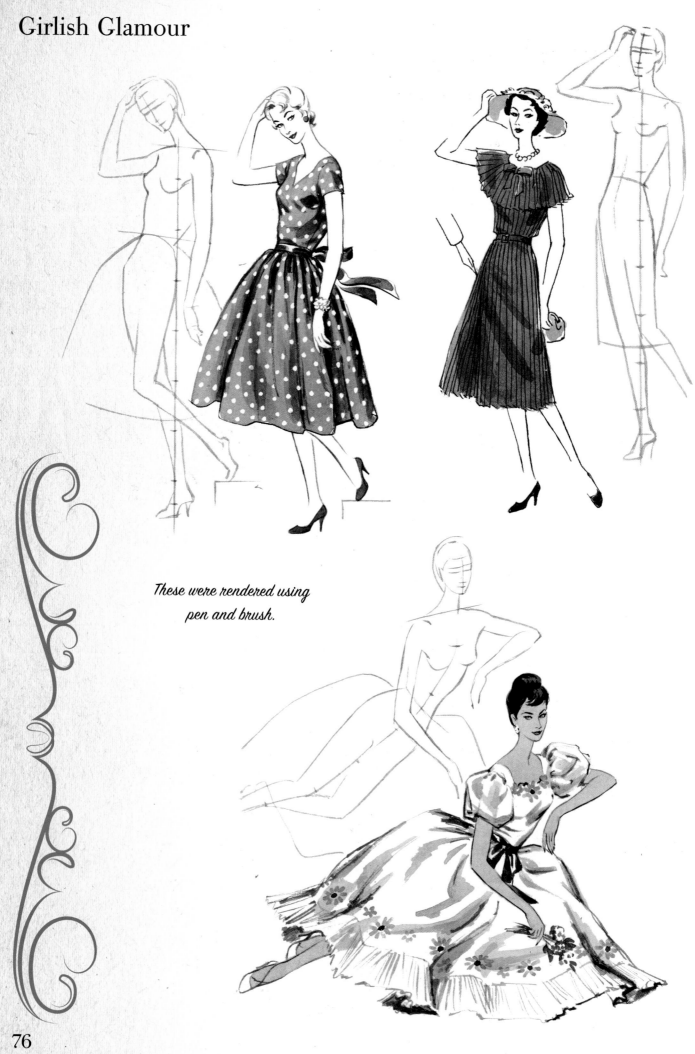

*These were rendered using
pen and brush.*

Lookbook: Eveningwear

One need think only of Audrey Hepburn in *Sabrina* (1954) and *Funny Face* (1957) for inspiration when fashioning the quintessential glamorous gown. With the help of costume design mastermind Edith Head, Hepburn made the ballerina skirt, pencil line dress, and bouffant gown the standard for evening chic.

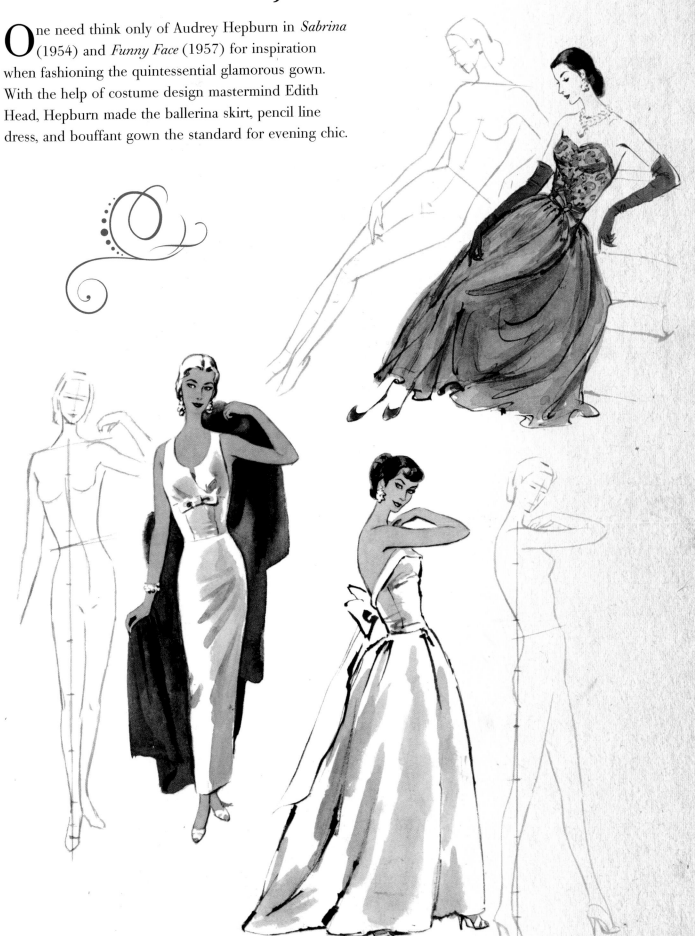

Lookbook: Lingerie

In the 1950s, the most popular lingerie reflected two women: the demure housewife and the vamp. The former gravitated toward silk slips, tasteful girdles, conservative nightgowns and men's-style pajamas. More provocative nighttime numbers, such as corselettes and garter belts, were for women who considered themselves more daring than darling.

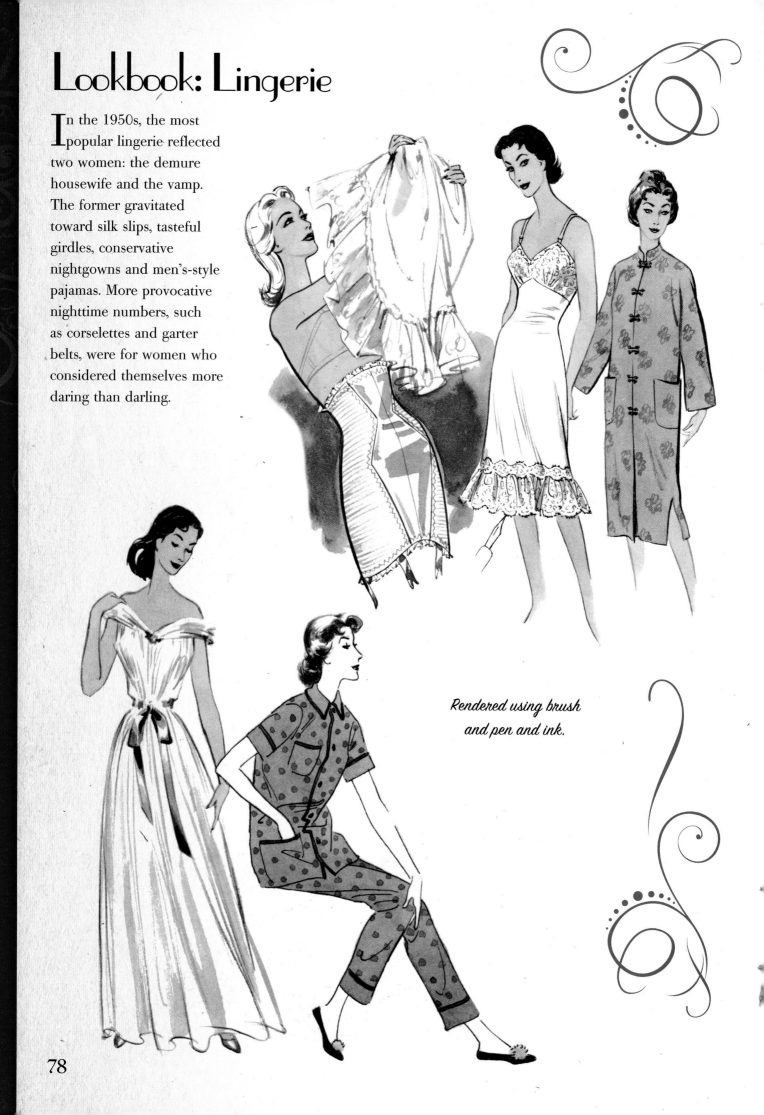

Rendered using brush and pen and ink.

Lookbook: Activewear

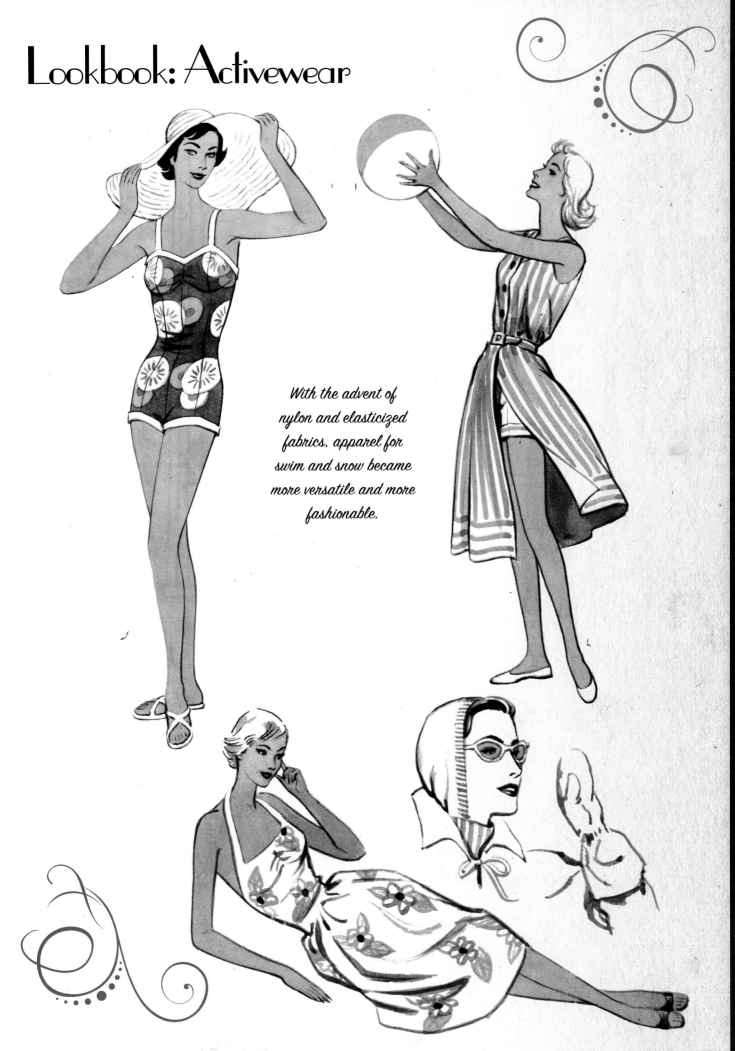

With the advent of nylon and elasticized fabrics, apparel for swim and snow became more versatile and more fashionable.

An Evening Out

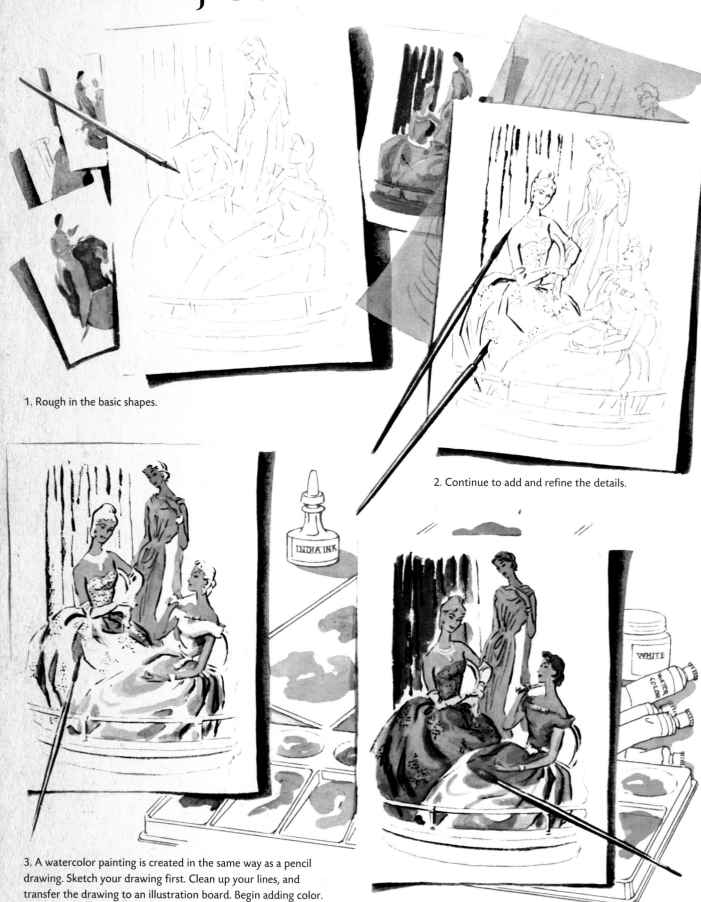

1. Rough in the basic shapes.

2. Continue to add and refine the details.

3. A watercolor painting is created in the same way as a pencil drawing. Sketch your drawing first. Clean up your lines, and transfer the drawing to an illustration board. Begin adding color.

Don't limit yourself. Learn how to use pen or brush, and try any new tools that might help you in your work.

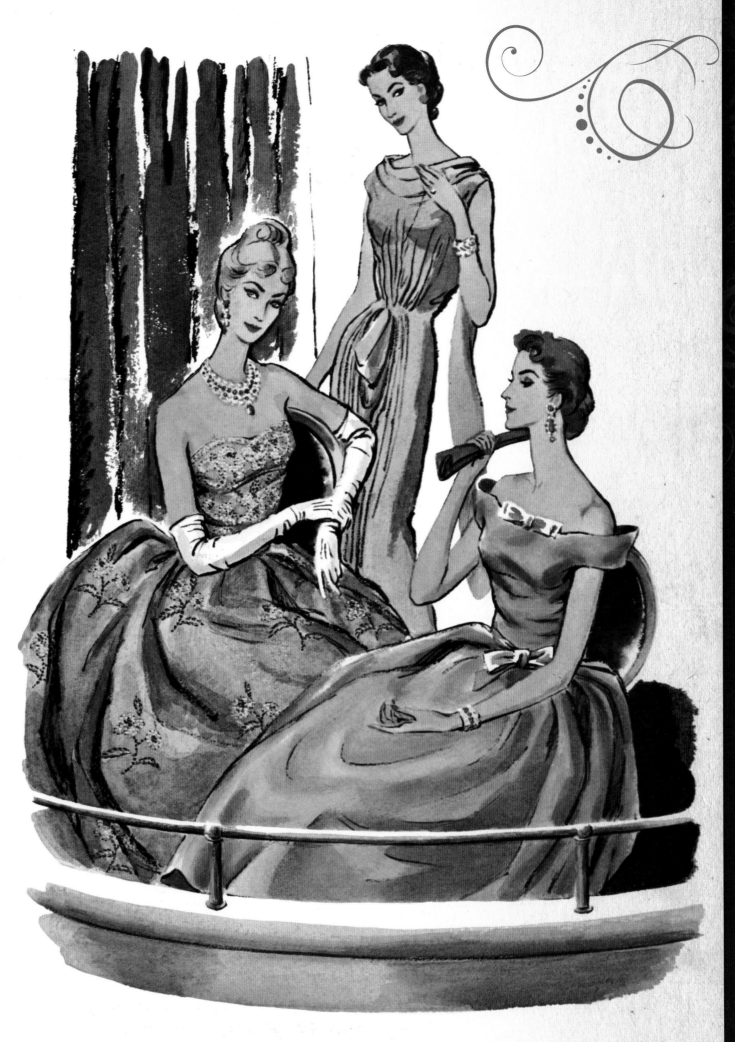

Chapter 5:
Early 1960s
Female Fashions
with Viola French

Although early 1960s fashion wasn't drastically different from fashion in the late 1950s, certain nuances signaled change on the horizon. Bright hues and bold patterns on otherwise 1950s-looking garments suggested a turn toward increased freedom and frivolity. The fact that women continued to wear dresses and skirts for most of their daily engagements, however, indicated that liberty from the structure of girdles and gloves was still a few years away. Such women as Jacqueline Kennedy, Julie Christie, and Sophia Loren, who stood out in the collective consciousness, also shaped the fashions the average woman wanted to wear. Pastel suits, pillbox hats, shift dresses, and gowns with ballerina skirts were in vogue for special occasions, as were Capri trousers, headscarves, and all things seersucker for casual days out.

The Face of Fashion

When drawing fashion faces, make sure that they exude as much smartness, sophistication, and charm as they do beauty. A study of early 1960s-era issues of *Harper's Bazaar, Vogue,* and *LIFE* magazines offers much insight into the intricacies of period makeup. Pay close attention to the arch of the eyebrow and the elongation of the eyes by way of heavier eyeliner and thicker, darker eyelashes.

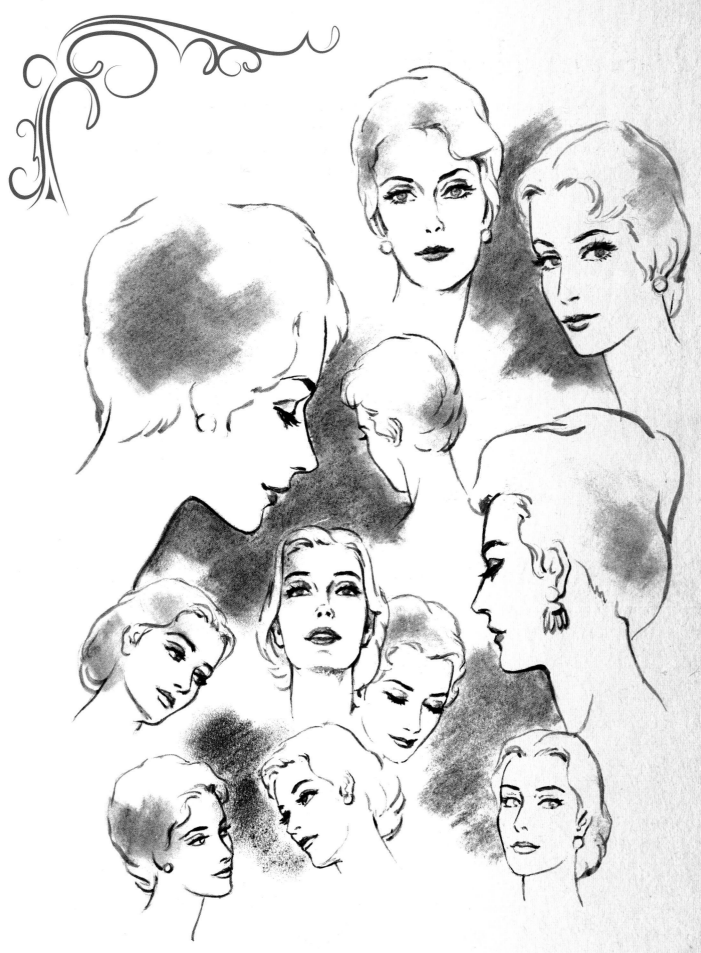

Study the people around you, taking note of the various head positions so that you can capture them in your drawings.

Hands & Feet

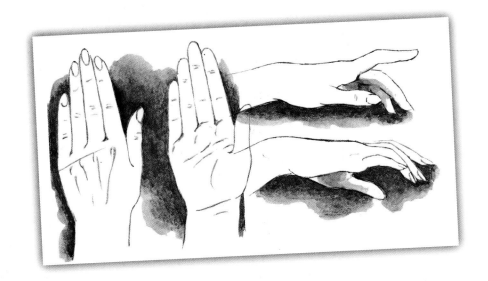

Observe your hands and notice the way your fingers look in a relaxed position. Pay close attention to the variations in the length of fingers, the orientation of knuckles, and the shape of hands when performing day-to-day activities.

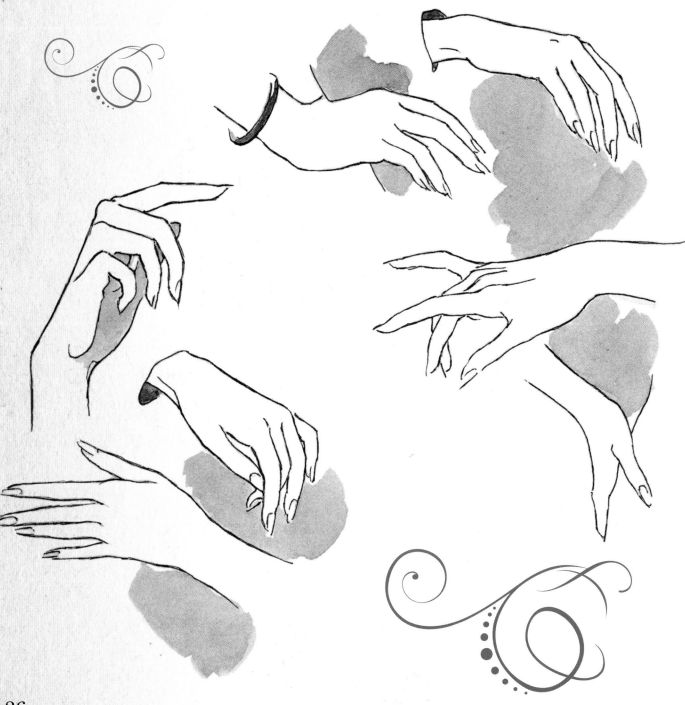

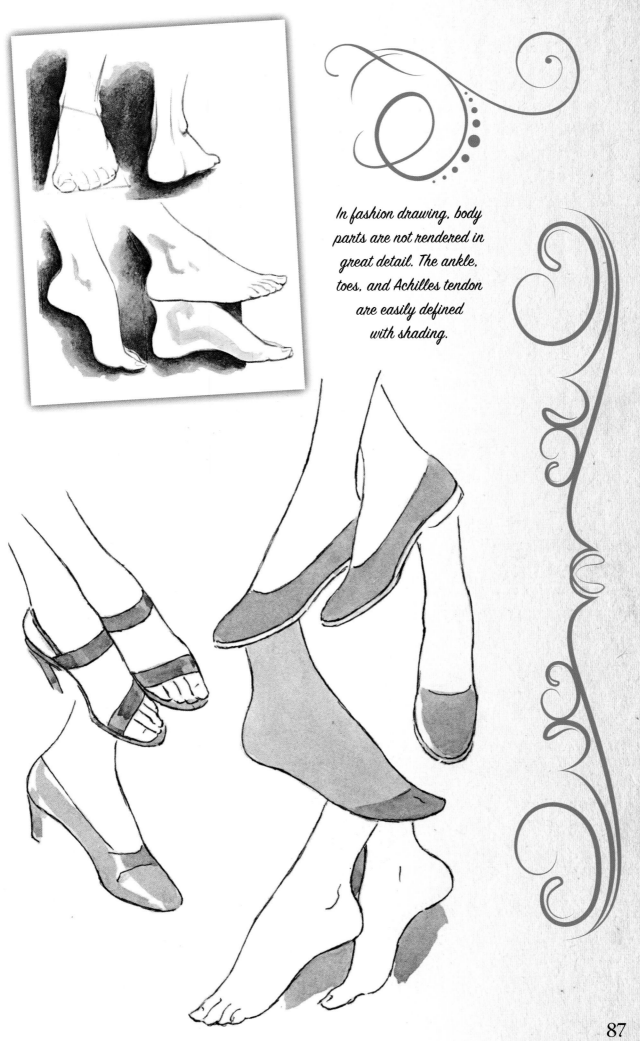

In fashion drawing, body parts are not rendered in great detail. The ankle, toes, and Achilles tendon are easily defined with shading.

Sources to Draw From

Examine the way body movements cause a variety of folds and how a thrust of the body causes tensions. When rendering the results, emphasize the important ones and omit the less important. Too many lines will confuse both you and the viewer.

Folds, Fabric & Patterns

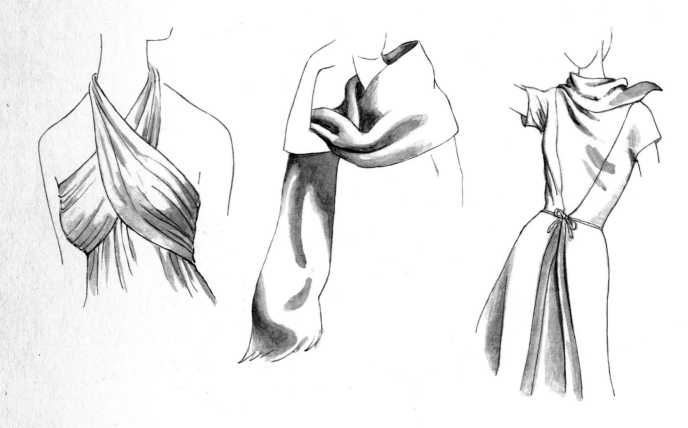

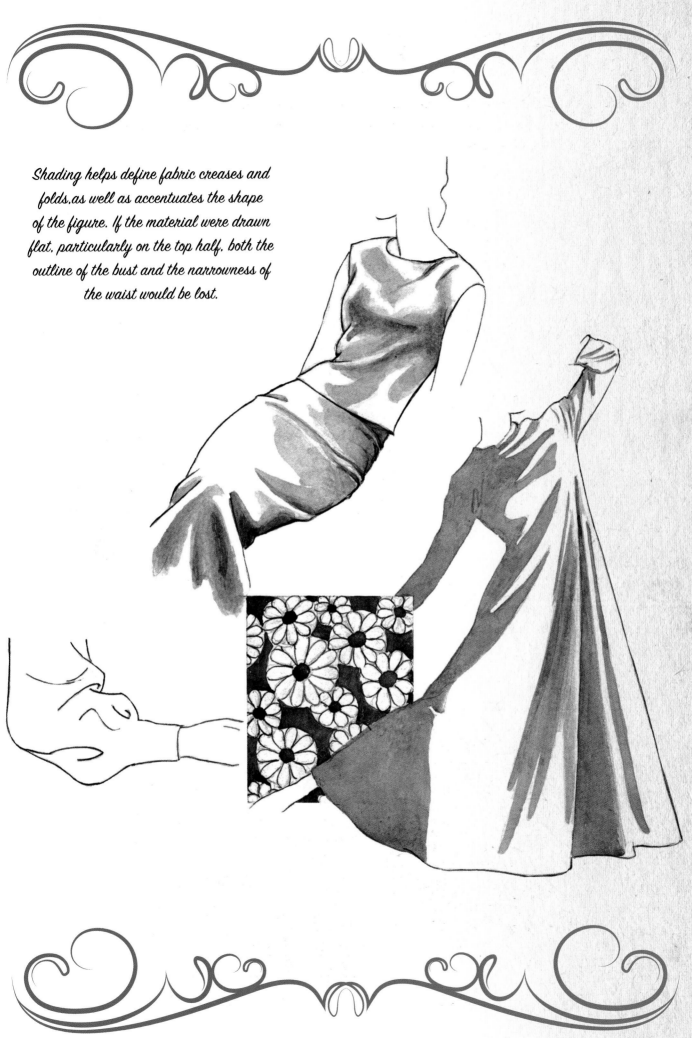

Shading helps define fabric creases and folds, as well as accentuates the shape of the figure. If the material were drawn flat, particularly on the top half, both the outline of the bust and the narrowness of the waist would be lost.

Poses

Trace over the figures on these pages and then add in fashions that complement each pose.

These were rendered using wash charcoal pencil.

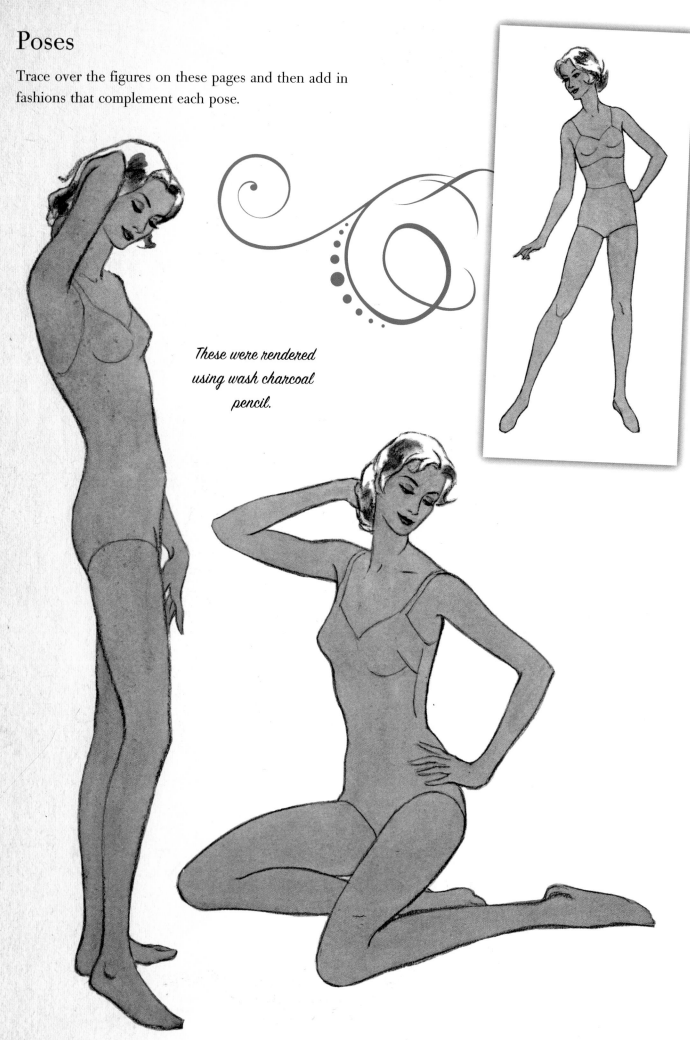

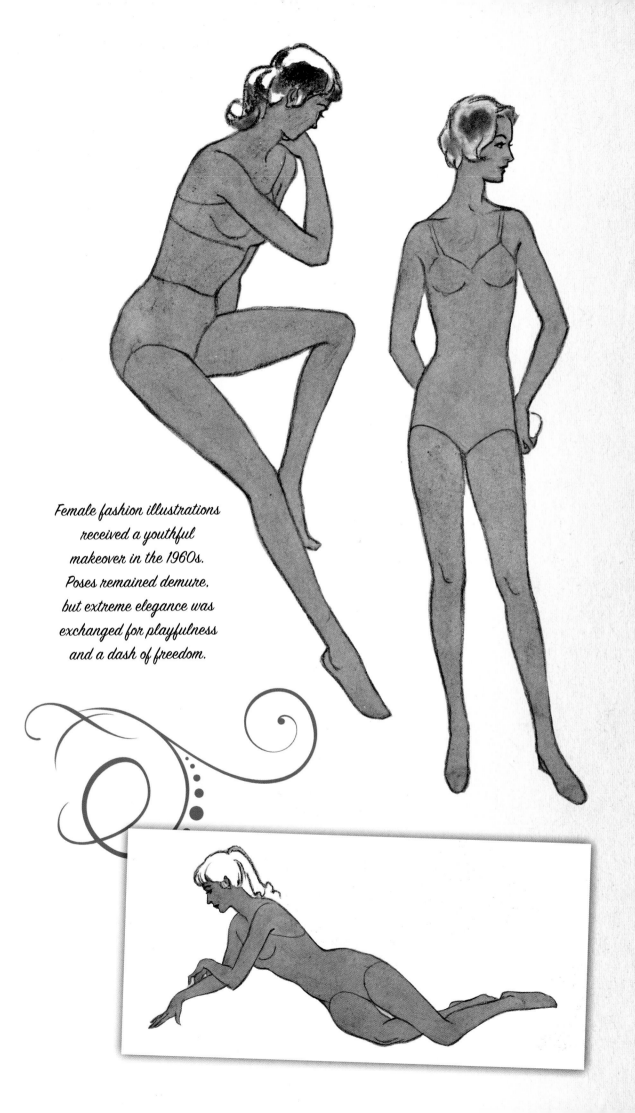

Female fashion illustrations received a youthful makeover in the 1960s. Poses remained demure, but extreme elegance was exchanged for playfulness and a dash of freedom.

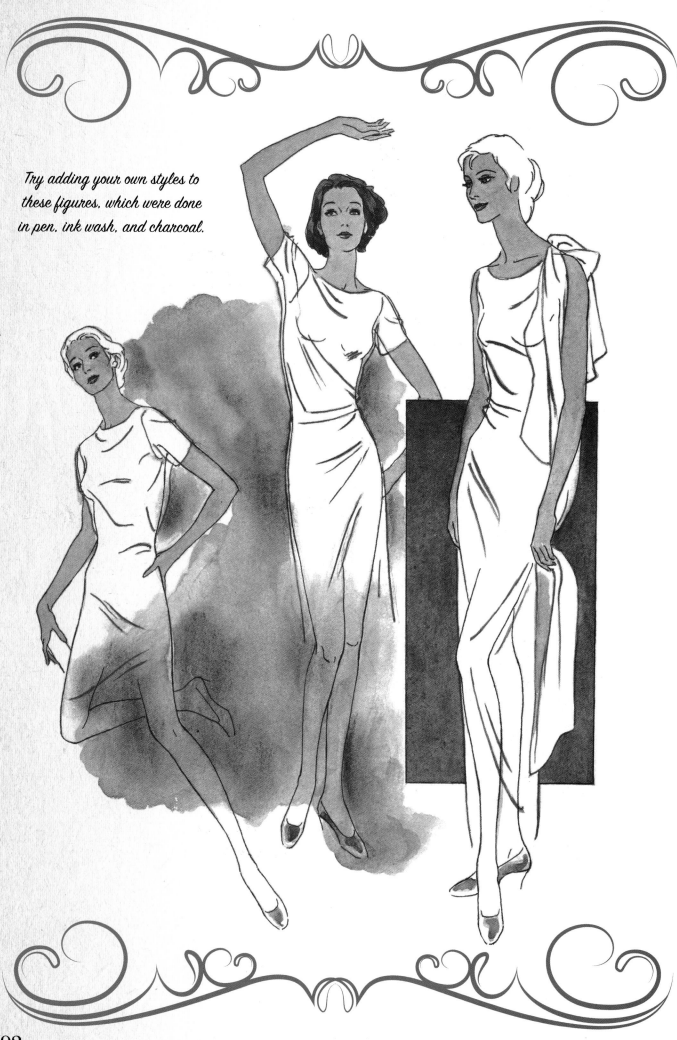

Try adding your own styles to these figures, which were done in pen, ink wash, and charcoal.

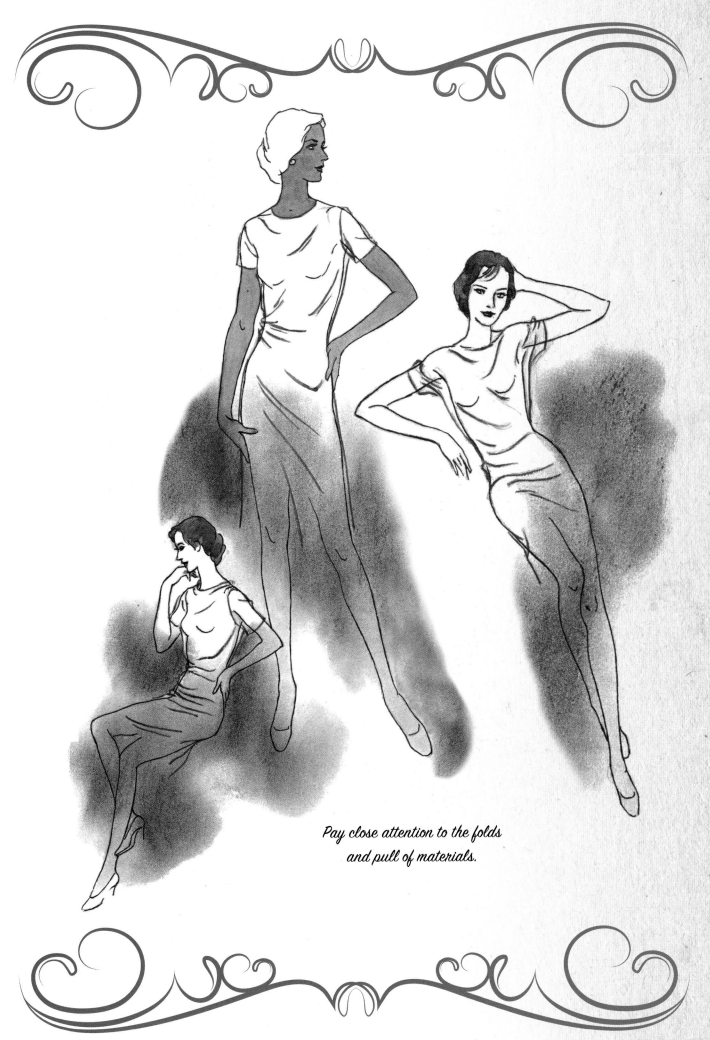

Pay close attention to the folds
and pull of materials.

Lookbook: Daywear

Daytime ensembles remained conservative in the 1960s, but a woman could demonstrate flair through her garment's details. A perfectly placed pocket or a sophisticated knot at the neck differentiated someone who knew how to wear clothes from someone who let the clothes wear her.

Separates

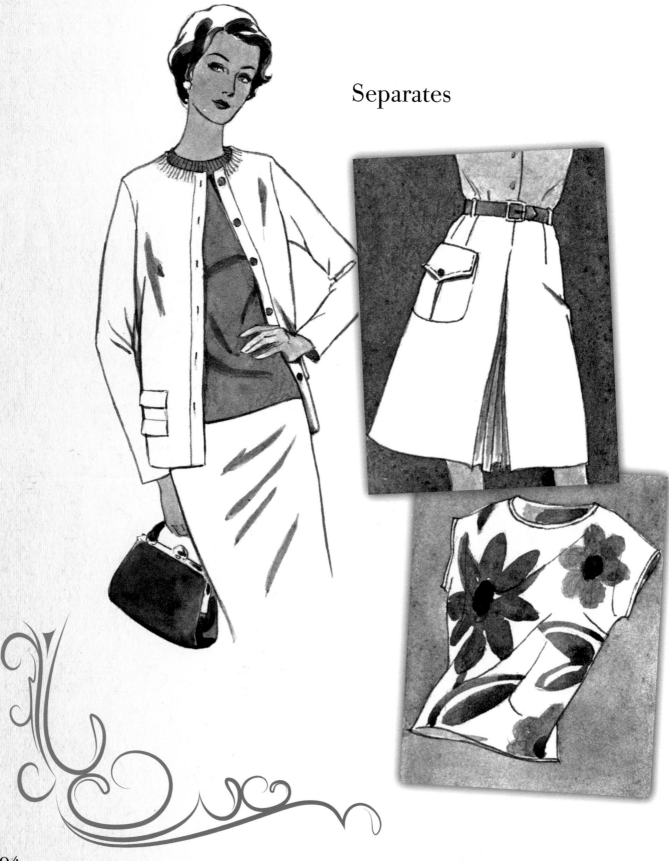

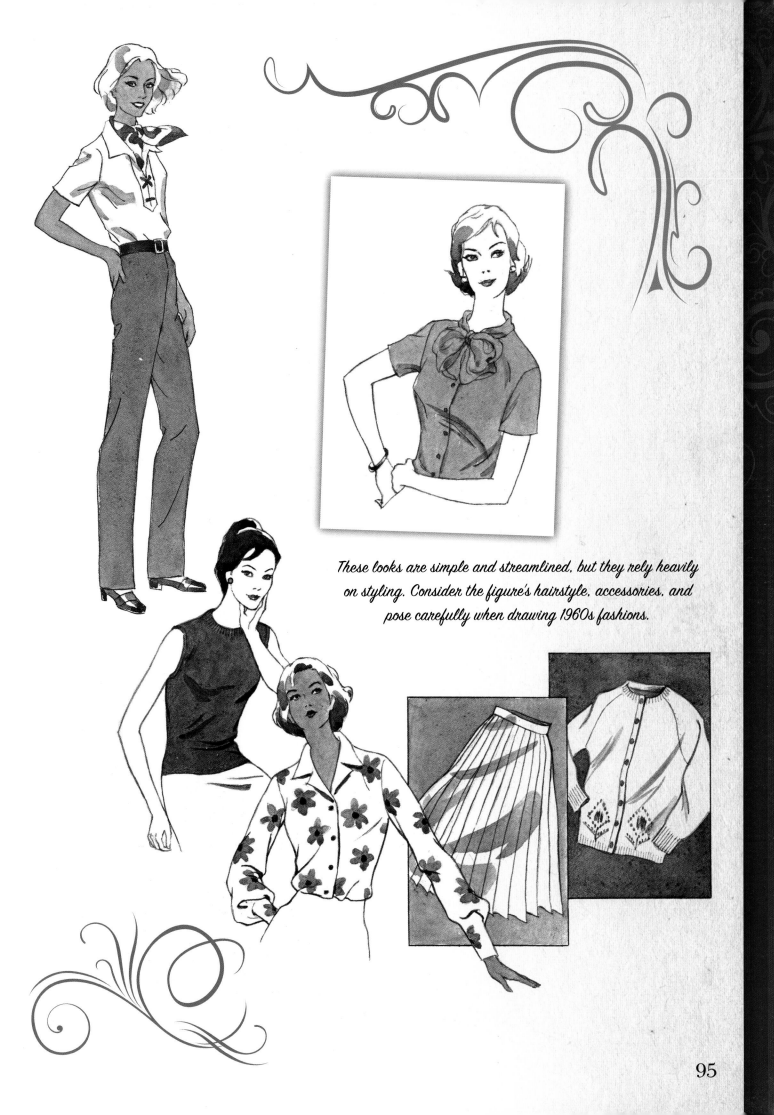

These looks are simple and streamlined, but they rely heavily on styling. Consider the figure's hairstyle, accessories, and pose carefully when drawing 1960s fashions.

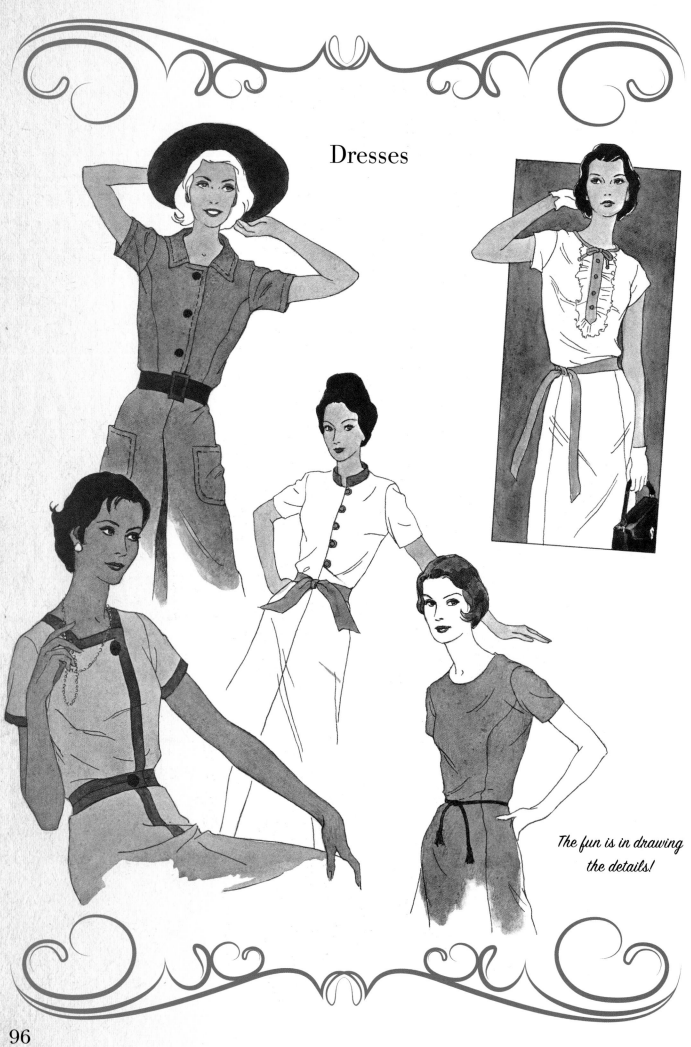

Dresses

The fun is in drawing the details!

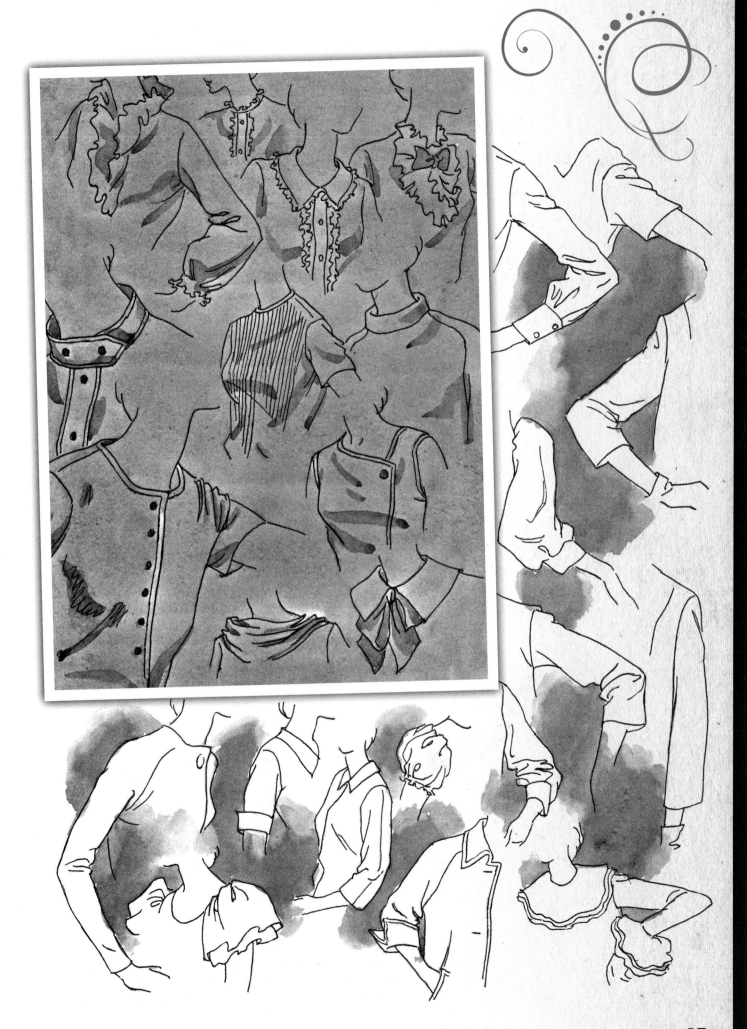

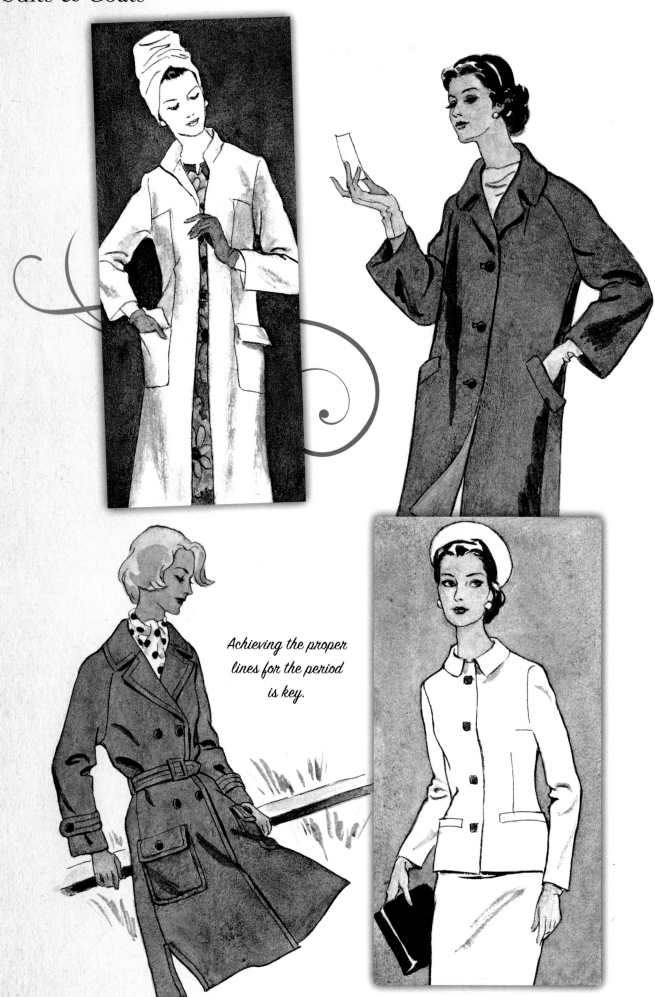

Achieving the proper lines for the period is key.

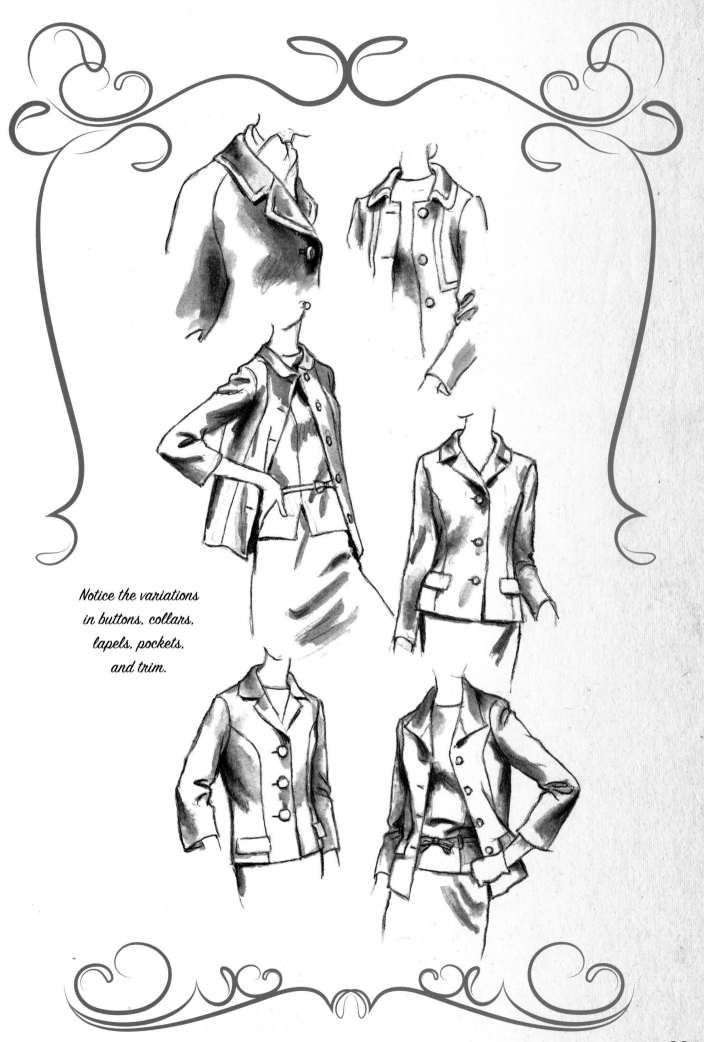

Notice the variations in buttons, collars, lapels, pockets, and trim.

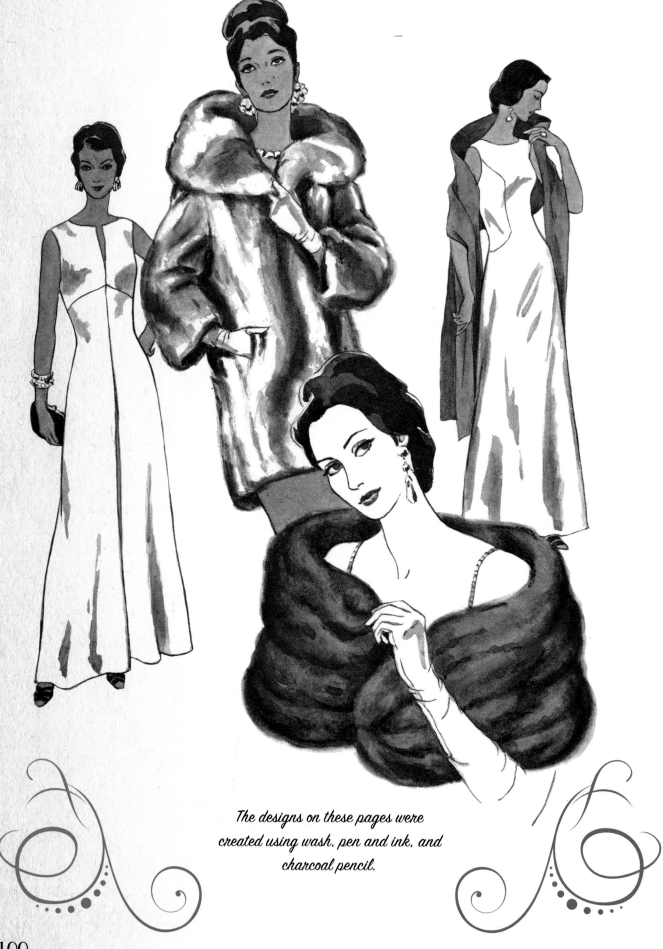

The designs on these pages were created using wash, pen and ink, and charcoal pencil.

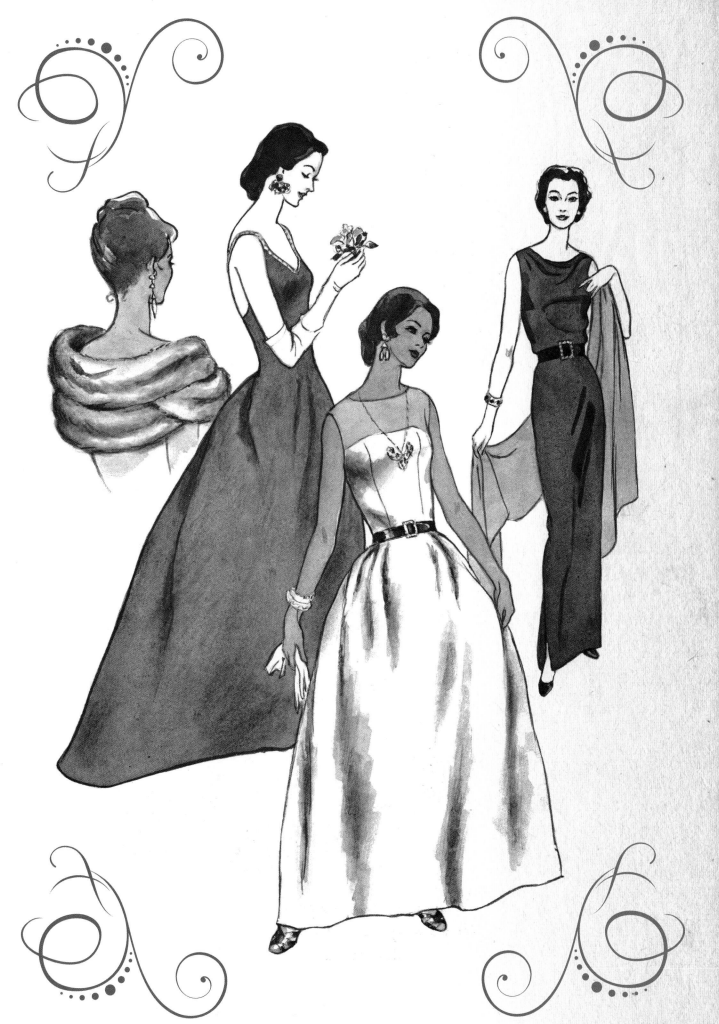

Lookbook: Bridal

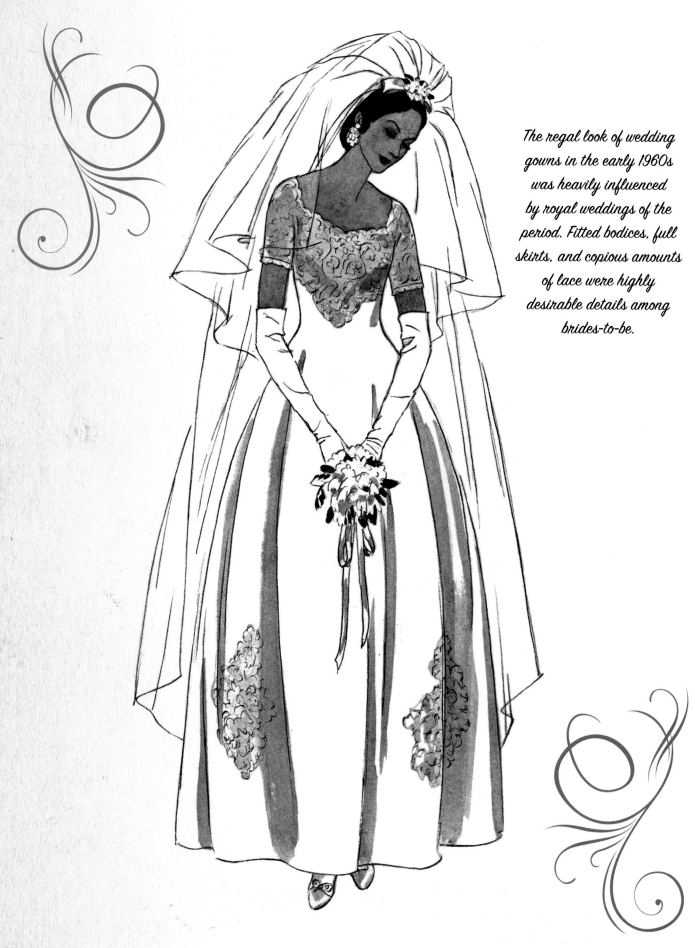

The regal look of wedding gowns in the early 1960s was heavily influenced by royal weddings of the period. Fitted bodices, full skirts, and copious amounts of lace were highly desirable details among brides-to-be.

Lookbook: Lingerie

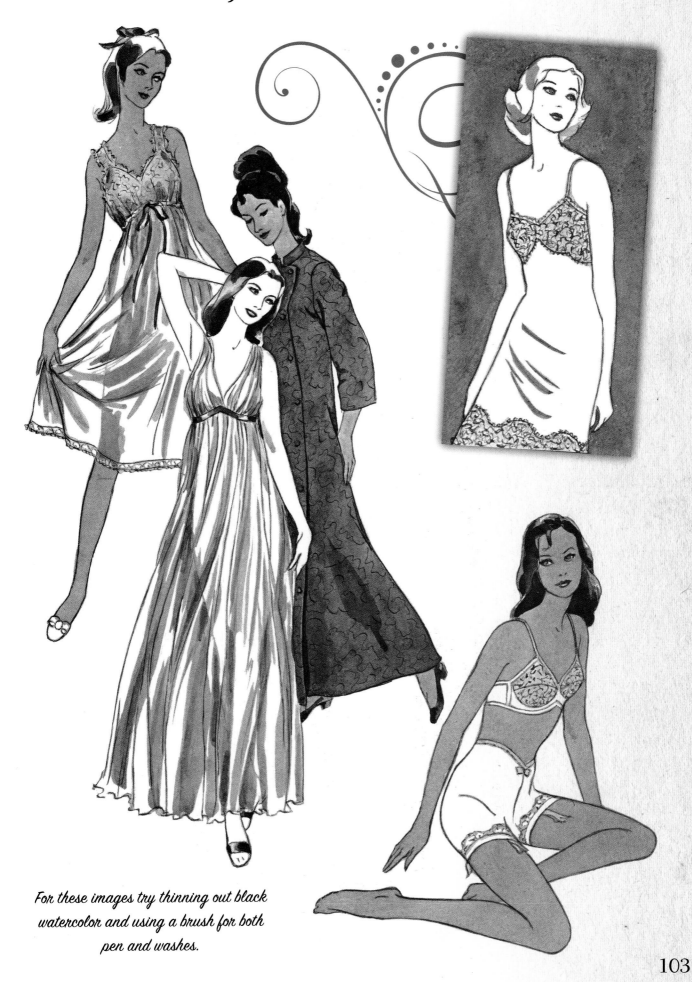

For these images try thinning out black watercolor and using a brush for both pen and washes.

Lookbook: Activewear

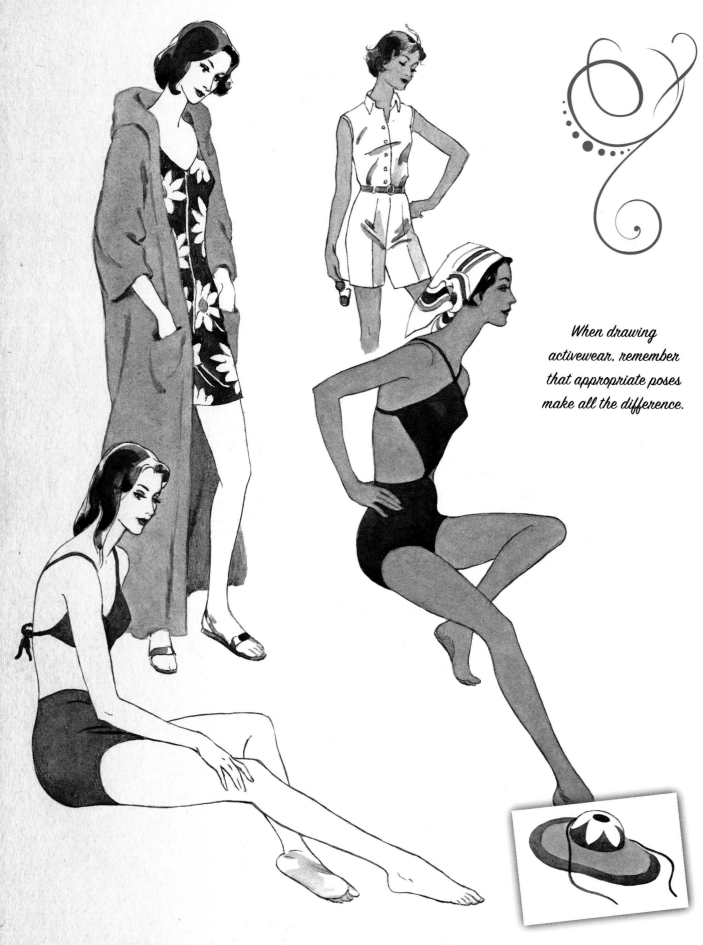

When drawing activewear, remember that appropriate poses make all the difference.

Lookbook: Accessories

Headwear

The placement of the hat on the head is important. Make sure your drawing captures the contours of the head.

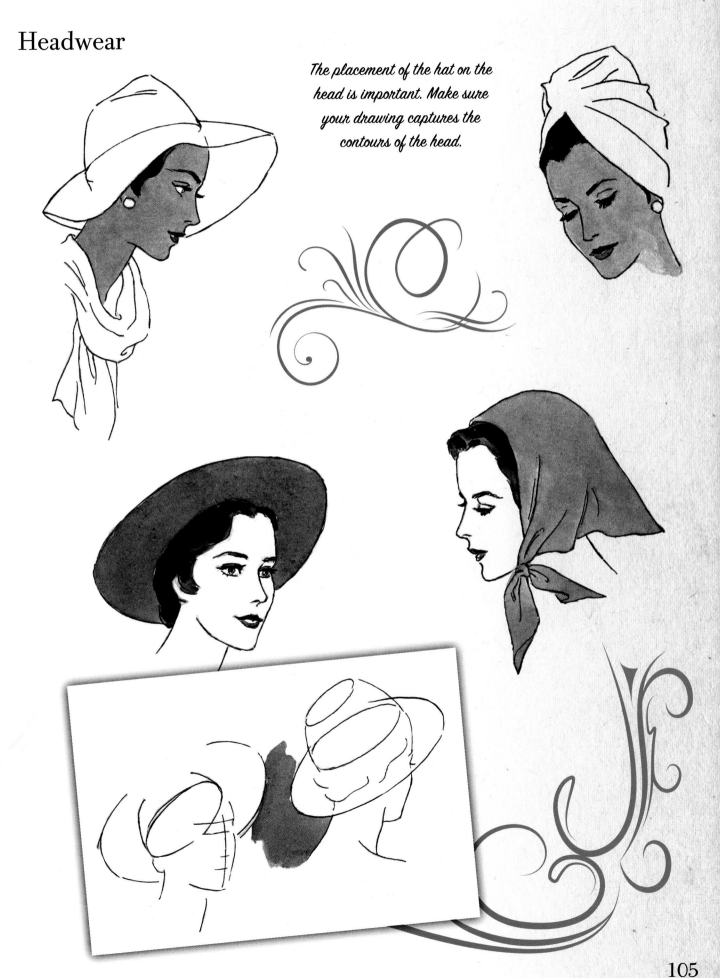

Accessories

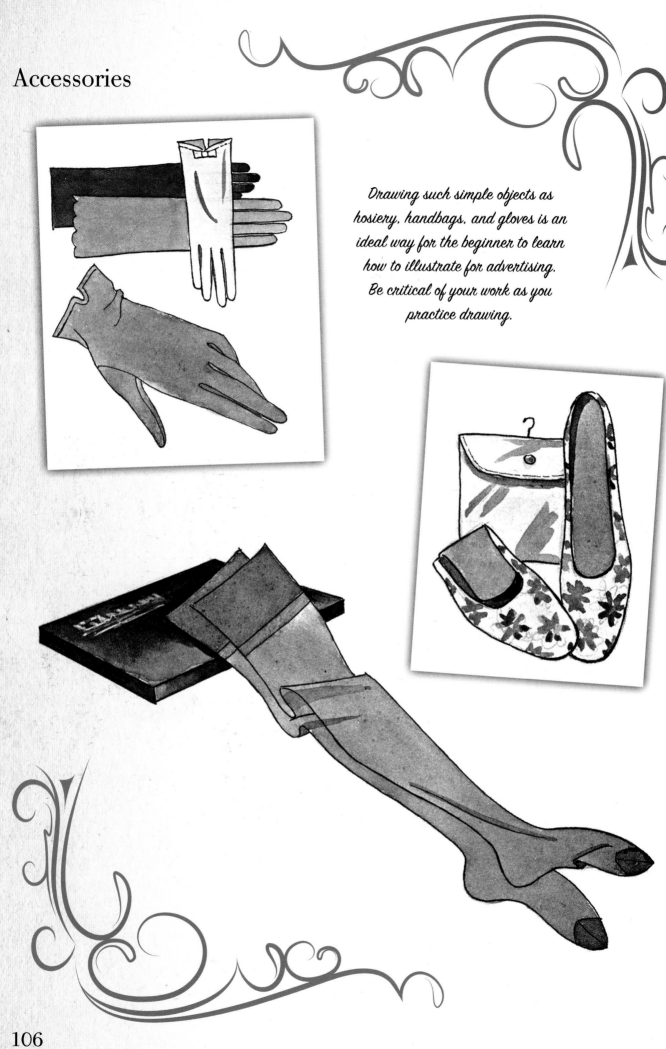

Drawing such simple objects as hosiery, handbags, and gloves is an ideal way for the beginner to learn how to illustrate for advertising. Be critical of your work as you practice drawing.

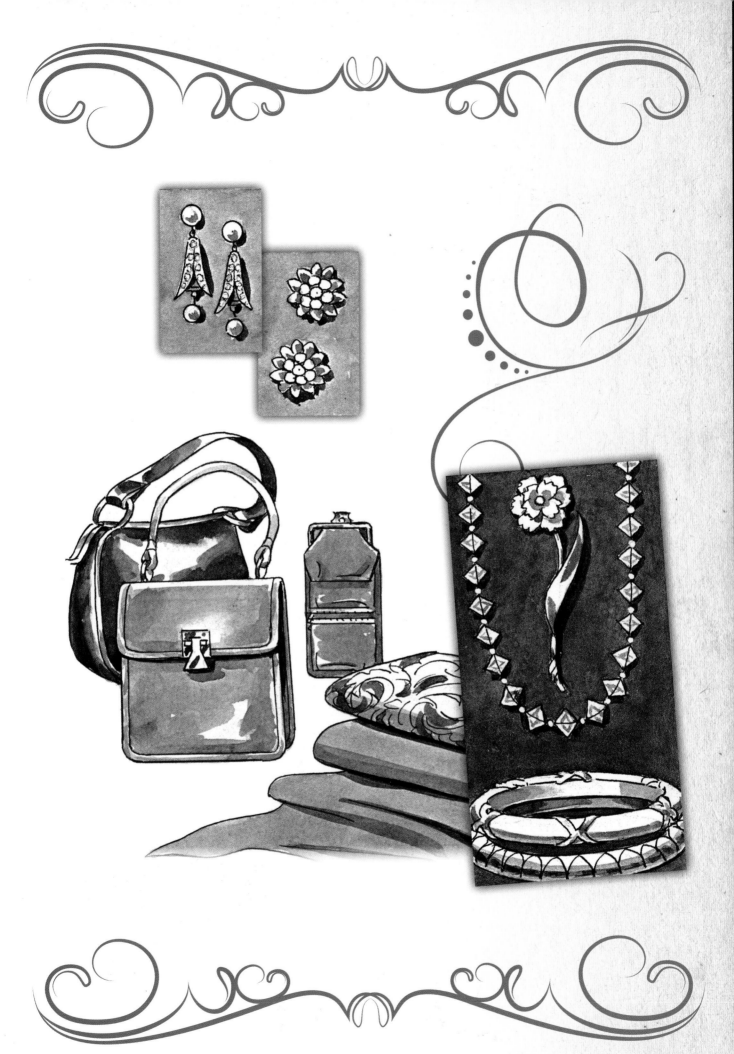

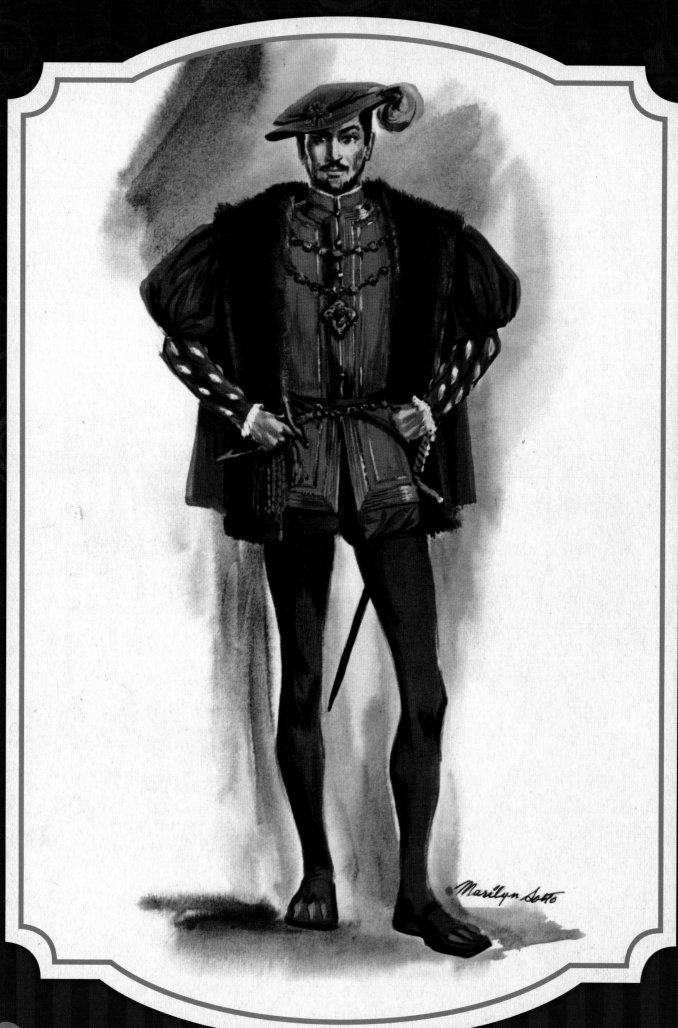

Chapter 6:
The Art of
Costume Design
with Marilyn Sotto

Marilyn Sotto began her illustrious career sketching and designing right out of high school. Prior to graduation, she took art courses and learned many tricks of the trade from her father, Ed Sotto, who also had a vast background in art. Major motion pictures for which she sketched and designed include *Around the World in Eighty Days* (1956), *The Ten Commandments* (1956), *Man of a Thousand Faces* (1957), *Raintree Country* (1957), and *Spartacus* (1960). Among the stars she helped costume were Anne Baxter, Yul Brynner, James Cagney, Joan Crawford, Charlton Heston, Dean Martin, Frank Sinatra, and Dick Van Dyke.

Period Costumes
Tudor Man

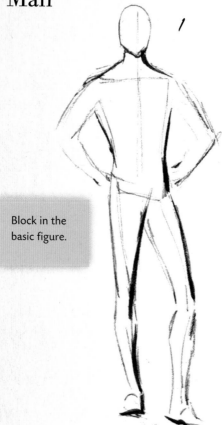

1

Block in the
basic figure.

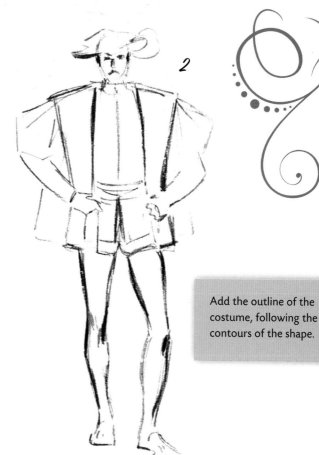

2

Add the outline of the
costume, following the
contours of the shape.

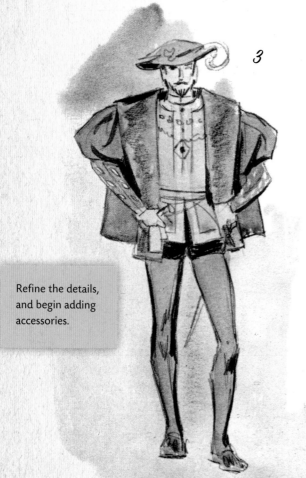

3

Refine the details,
and begin adding
accessories.

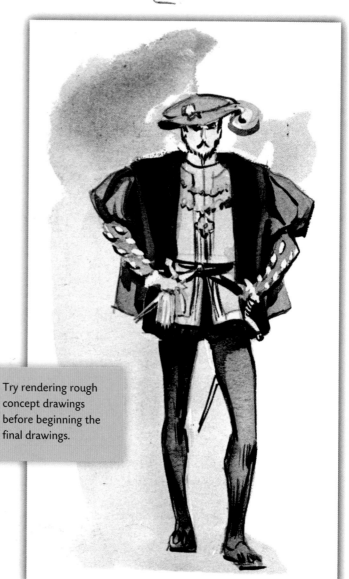

Try rendering rough
concept drawings
before beginning the
final drawings.

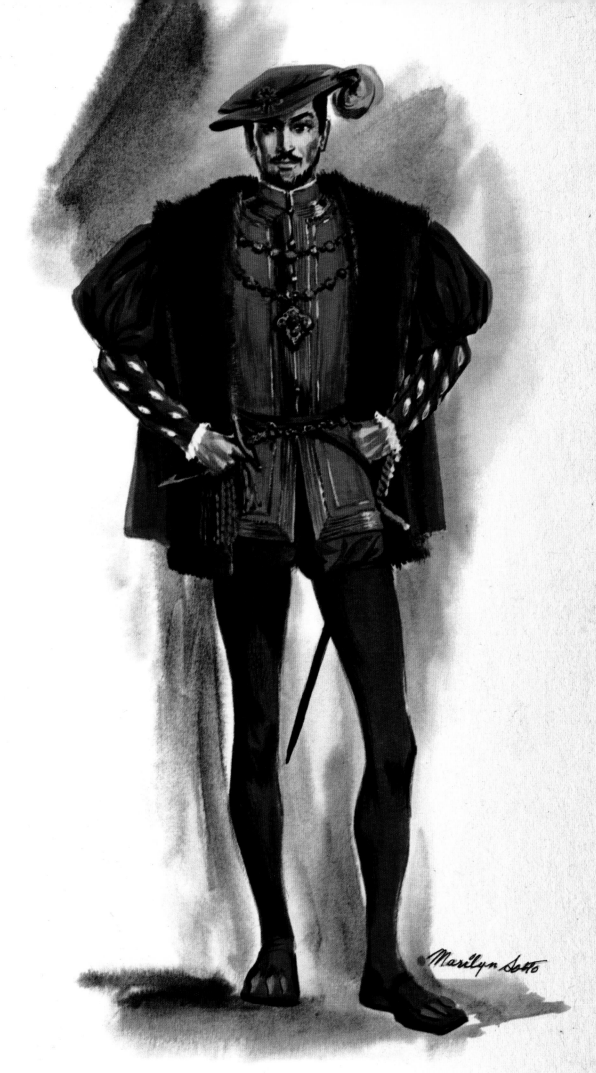

Tudor Woman

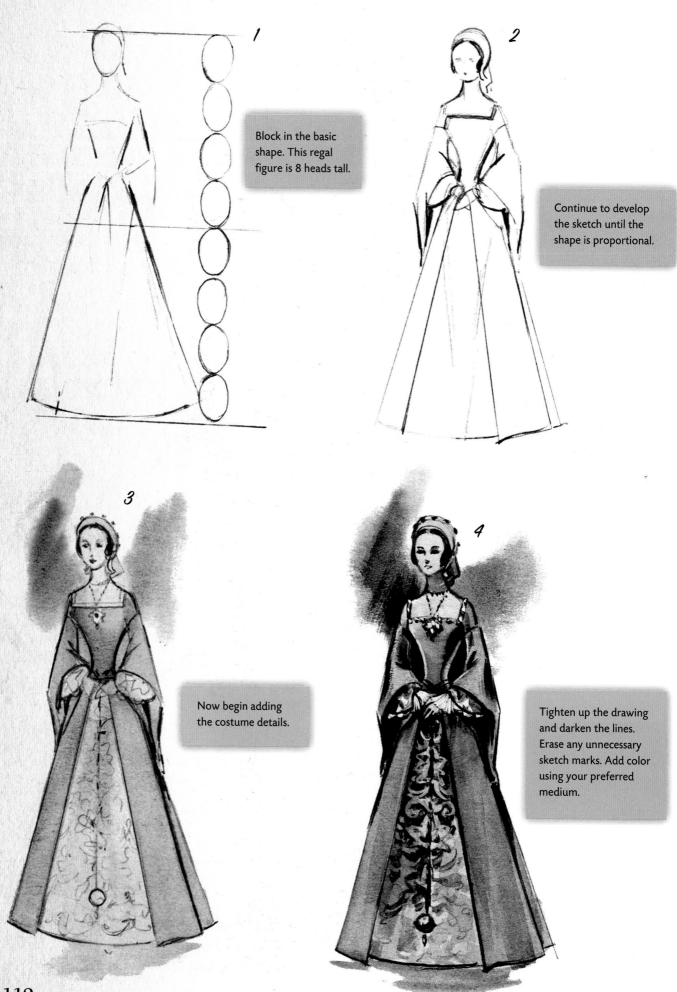

1 Block in the basic shape. This regal figure is 8 heads tall.

2 Continue to develop the sketch until the shape is proportional.

3 Now begin adding the costume details.

4 Tighten up the drawing and darken the lines. Erase any unnecessary sketch marks. Add color using your preferred medium.

When painting a brocade, start with the lightest color first, allow it to dry, and then paint in a darker tone. Shadow the gown gradually, using one or two slightly darker tones. To paint velvet, use the dry-brush technique, accenting deeper shadows with the darkest tone of fabric.

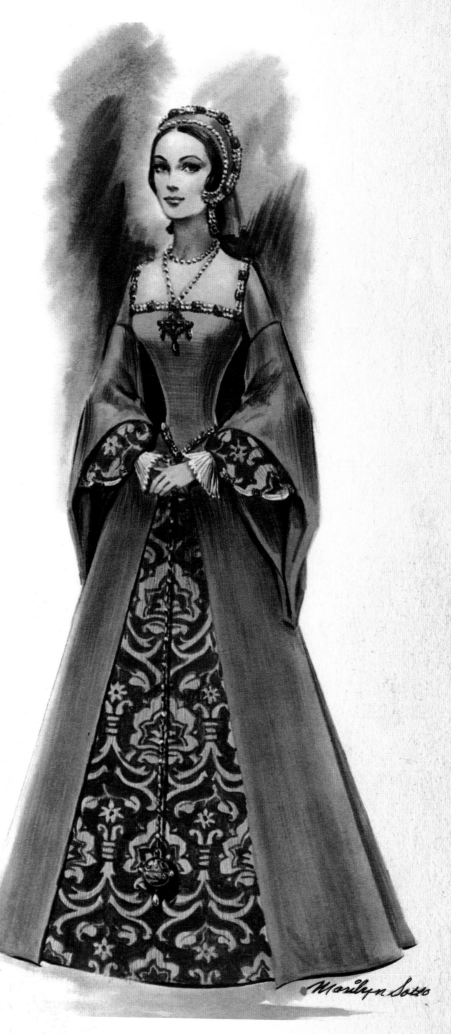

Marilyn Sotto

Louis XVI Man

1

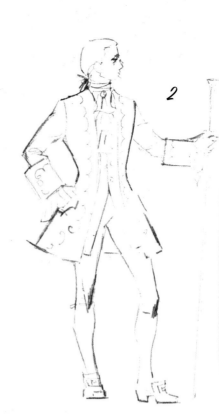

2

Block in the basic shape.

The designer should consider the textures and patterns when working out the details of a costume. Tissue paper "roughs" or "thumbnails" can help create the effect.

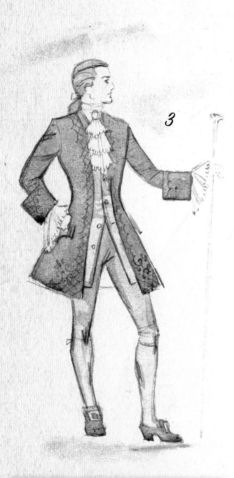

3

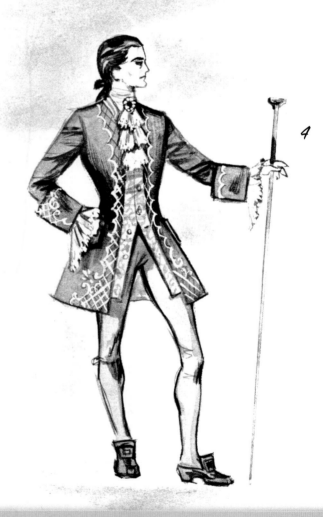

4

Working out the detailing in advance saves time when scaling it to size for the embroiderers.

Any little touch of character the designer adds to the sketch may be of immeasurable assistance to the actor. Many designers have been responsible in helping to determine the approach an actor takes in accordance with his or her character.

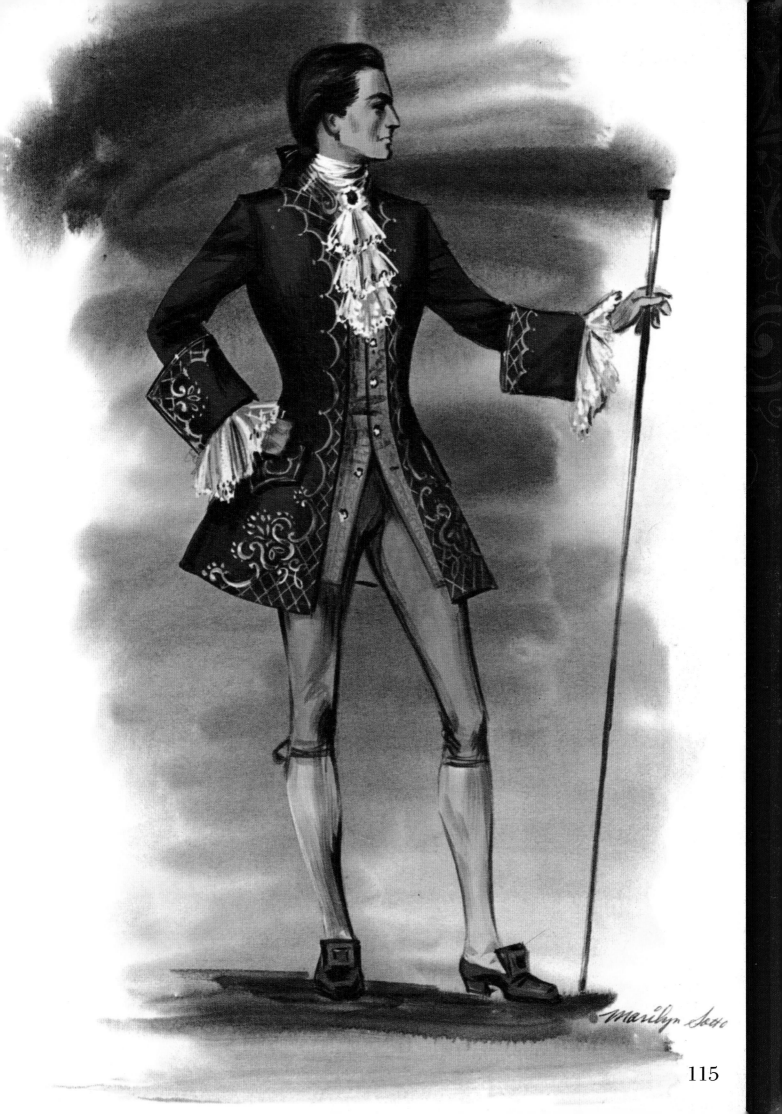

Louis XVI Woman

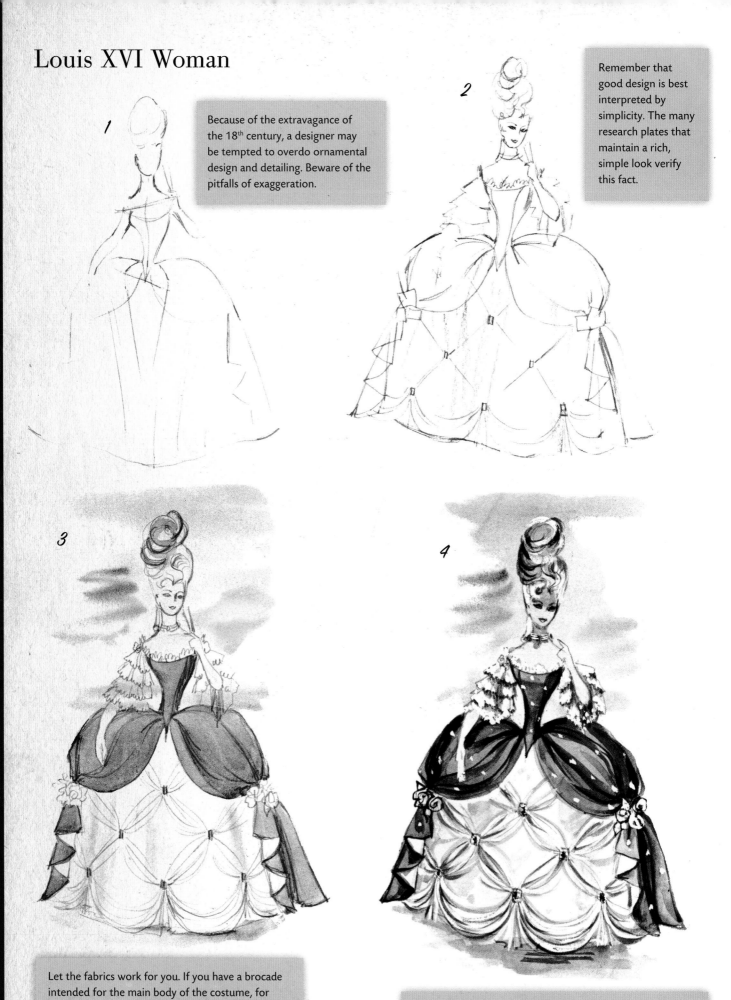

Because of the extravagance of the 18th century, a designer may be tempted to overdo ornamental design and detailing. Beware of the pitfalls of exaggeration.

Remember that good design is best interpreted by simplicity. The many research plates that maintain a rich, simple look verify this fact.

Let the fabrics work for you. If you have a brocade intended for the main body of the costume, for example, offset it with a plain fabric for the lesser part. Use jewels and sequins to tastefully ornament the less embellished areas.

Bows, birds, flowers, tassels, and jewels were used for trimming; however, do not use them all on one costume. Choose one or two items at most. For this image, gold roses and purple stones were used sparingly.

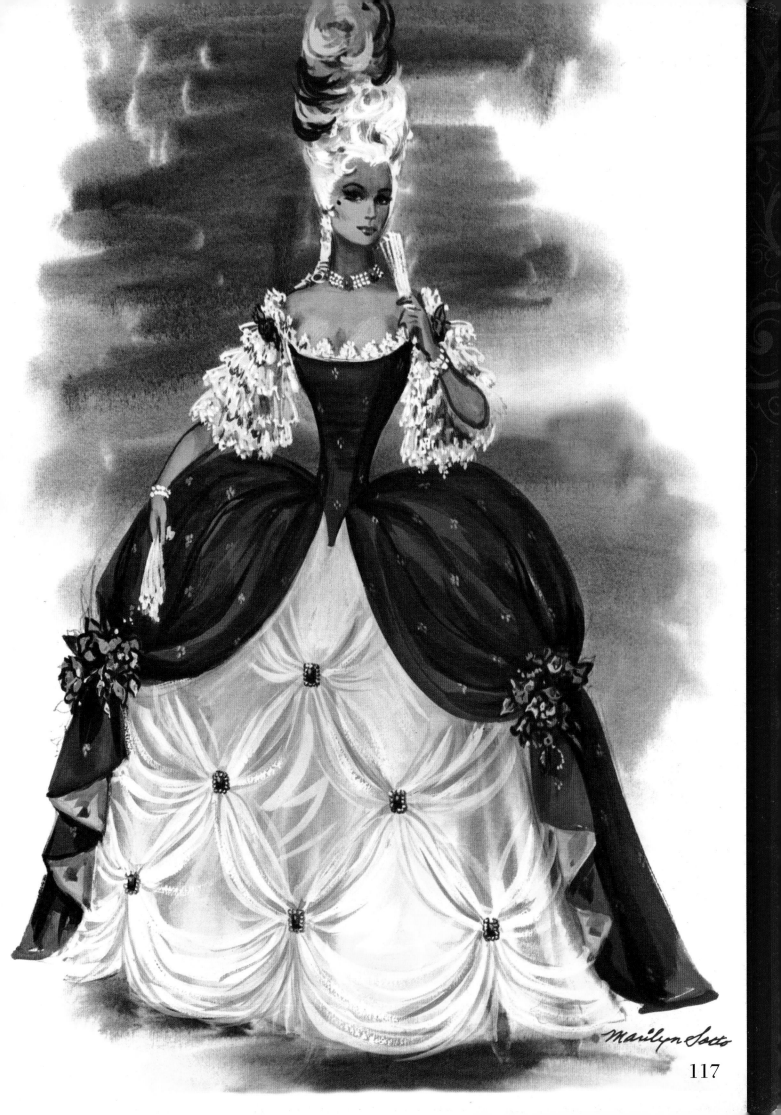

Marilyn Sotto

Julius Caesar

1

Where draping is involved, be sure not to lose the shape of the torso beneath in the completed sketch.

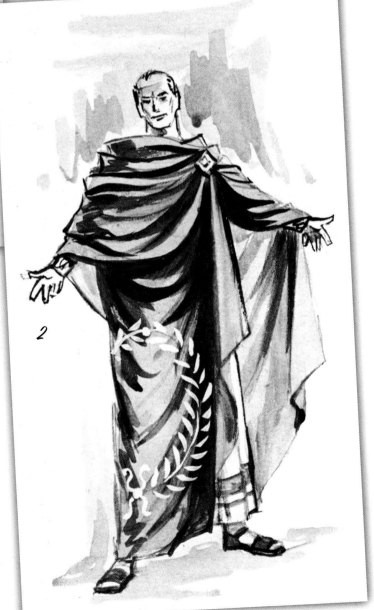

2

There are plenty of research books to formulate designs for togas, undergarments, belts, and leather sandals. When rendering togas, there are two basic designs for shaping the cloth: the complete oval or the half oval. As for undergarments, there should be some knowledge as to whether or not the tunics were belted, pleated, or hung loosely on the body.

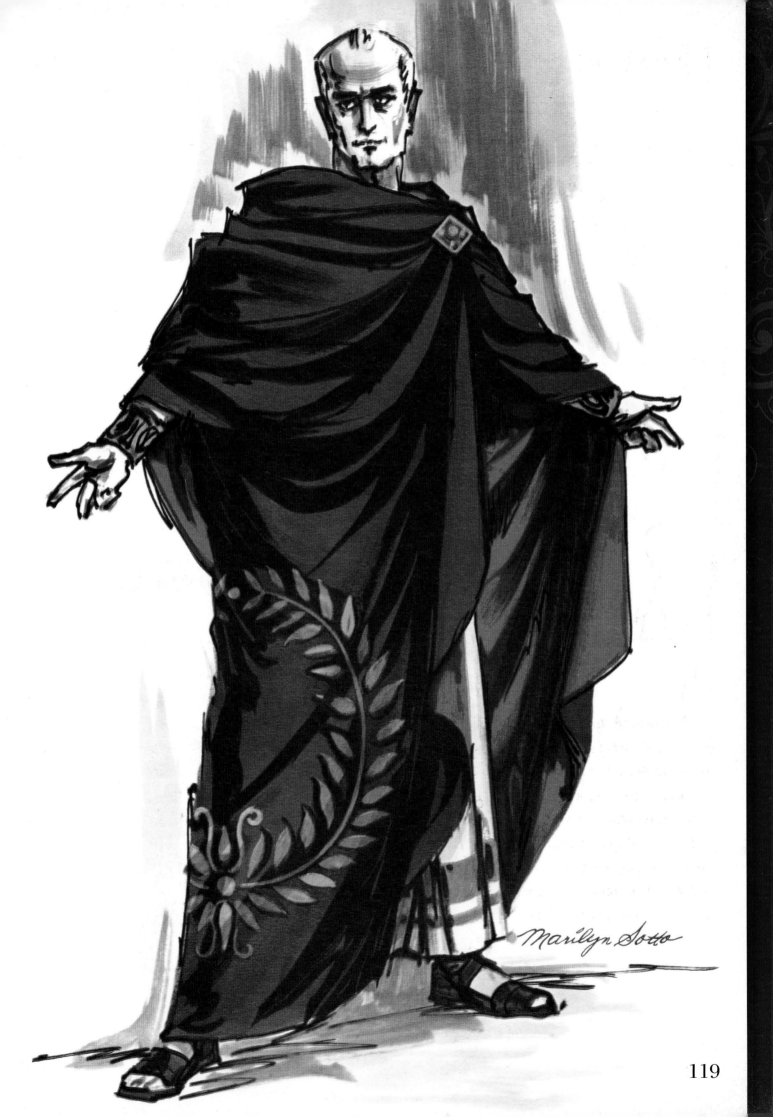

Marilyn Sotto

Roman Women

Note that the sketching technique has changed again, this time to a flatter, more stylized feeling. By practicing new and different techniques, the designer becomes more versatile.

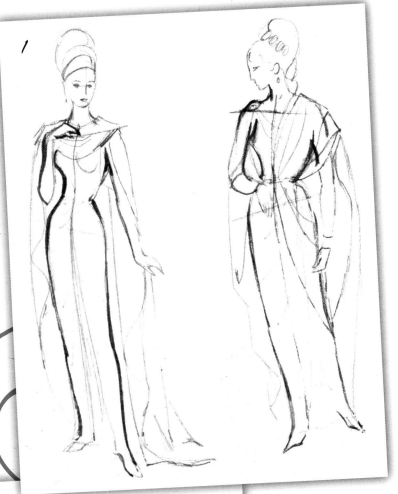

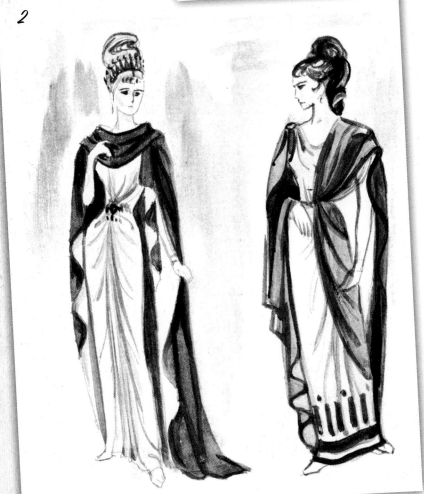

The color approach used in this example for stage costuming features muted, earthen tones. Always consider the scene the actors are playing, and try to adapt the costumes to the mood.

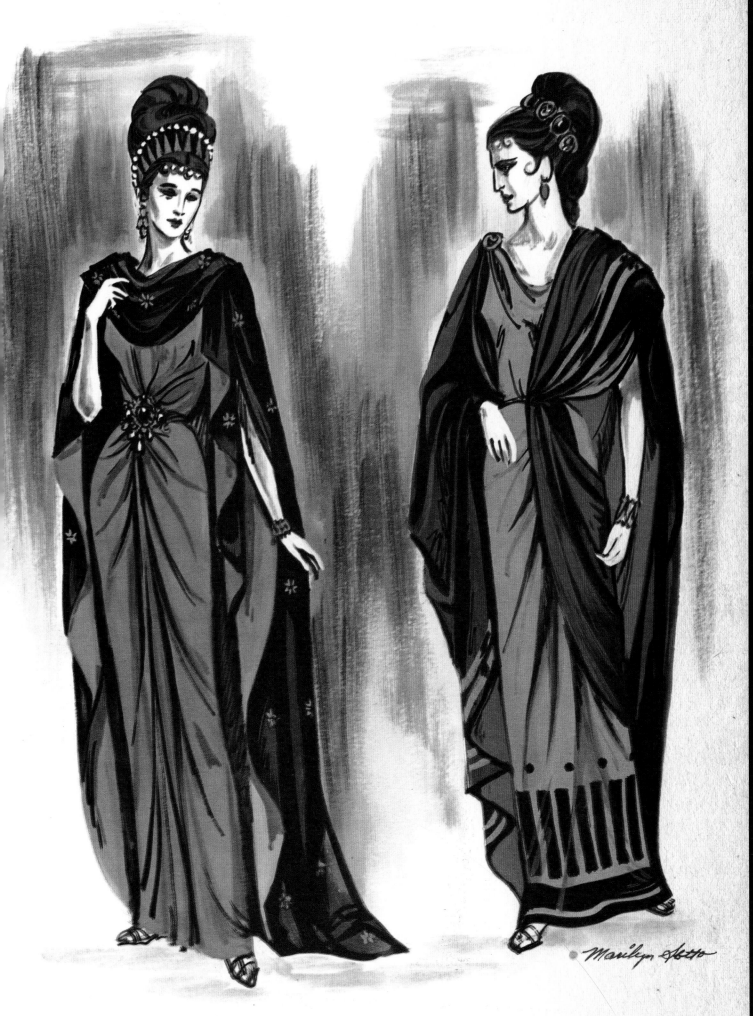

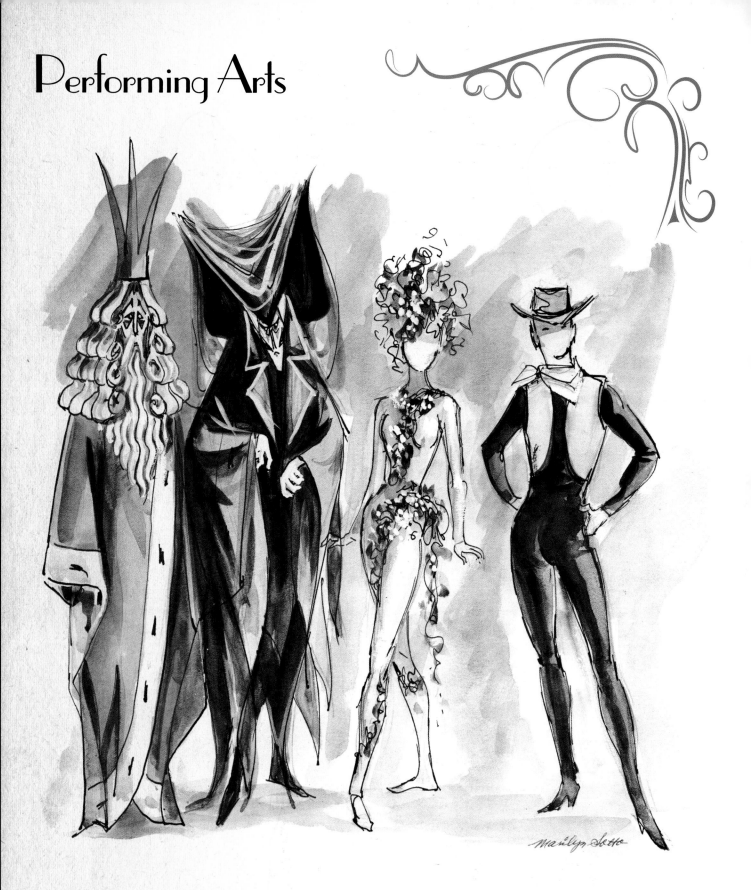

This drawing was done in a quick, yet effective, manner. Future costume designers for the ballet should learn everything possible about the art form in order to become aware of the limitations involved when designing for such a body-conscious medium.

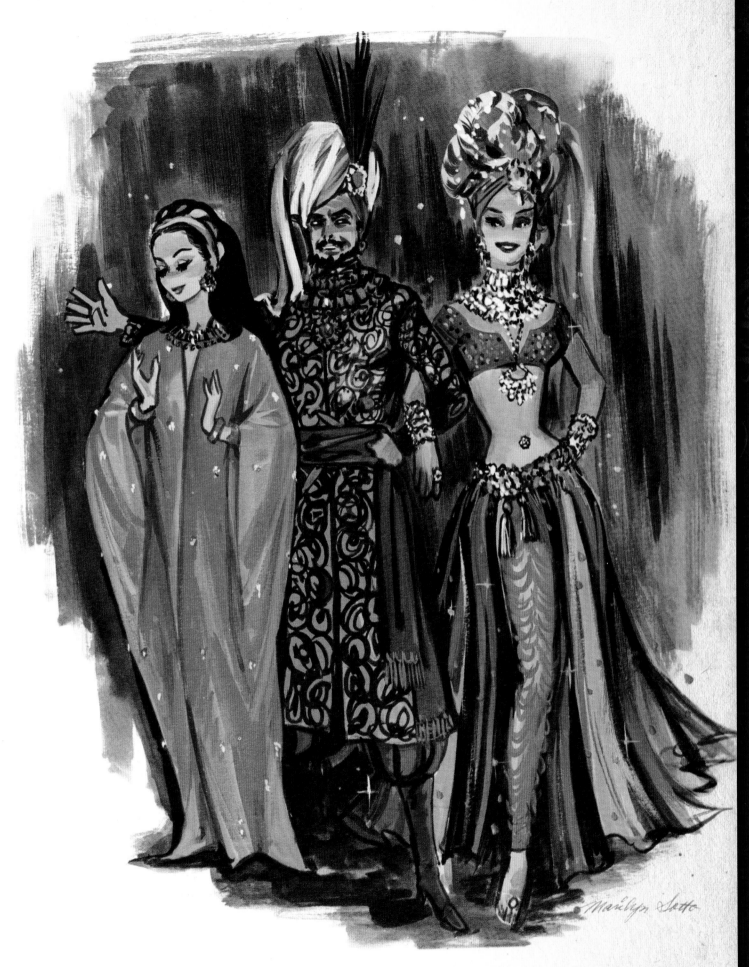

The designer may want to employ one color range for an entire production. If he or she chooses red, costumes would range from the hottest reds, to pinks, to oranges, and would be cooled off with burnt orange and deep reds. If a leading lady is attired in pink throughout a musical, the designer should vary her costume changes with several tones or degrees of pink. Another choice is to do a show using three distinct groups of color, with varying shades in each group.

Sometimes producers request a group of figures on one sketch. This enables them to get a better idea of how a particular scene will play based on the costumes. Note how each character contrasts with the other players, yet blends into the entire sketch.

Always keep in mind the type of character and actress for whom you are costuming and then design accordingly. Depending on physique, some actresses may look best in tailored clothes, rather than ruffles and frills.

Showgirls

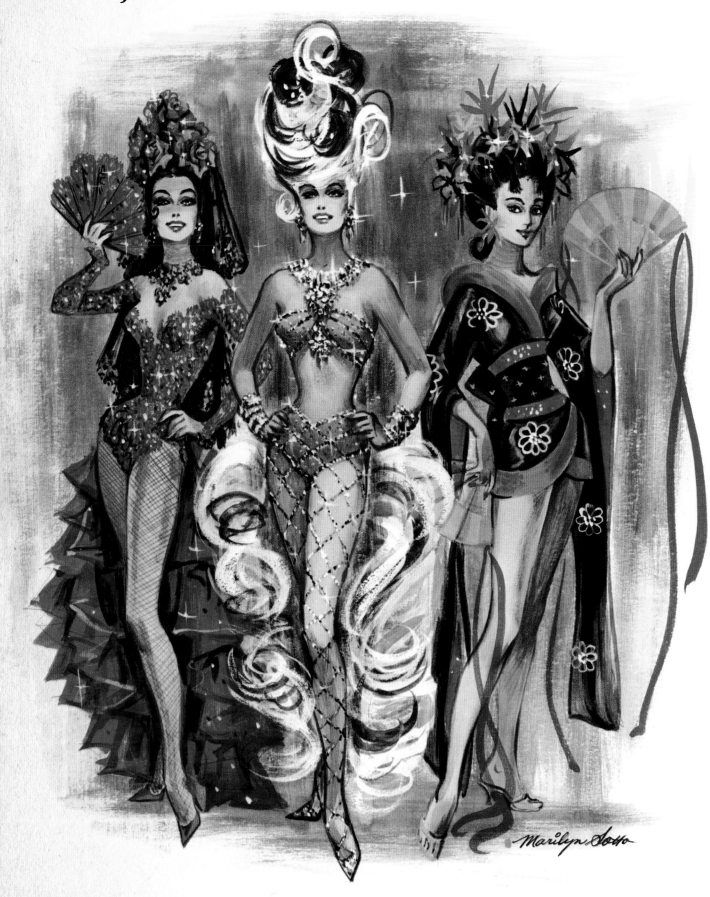

Showgirls afford the designer the opportunity to exploit the imagination to its fullest extent in all its colorful glory. There are a variety of themes to choose from when designing for a large revue, including the seasons, flowers, birds, celestial bodies, or precious gems. Each is an island unto itself and allows the designer an almost endless possibility of ideas.

Costume Couture

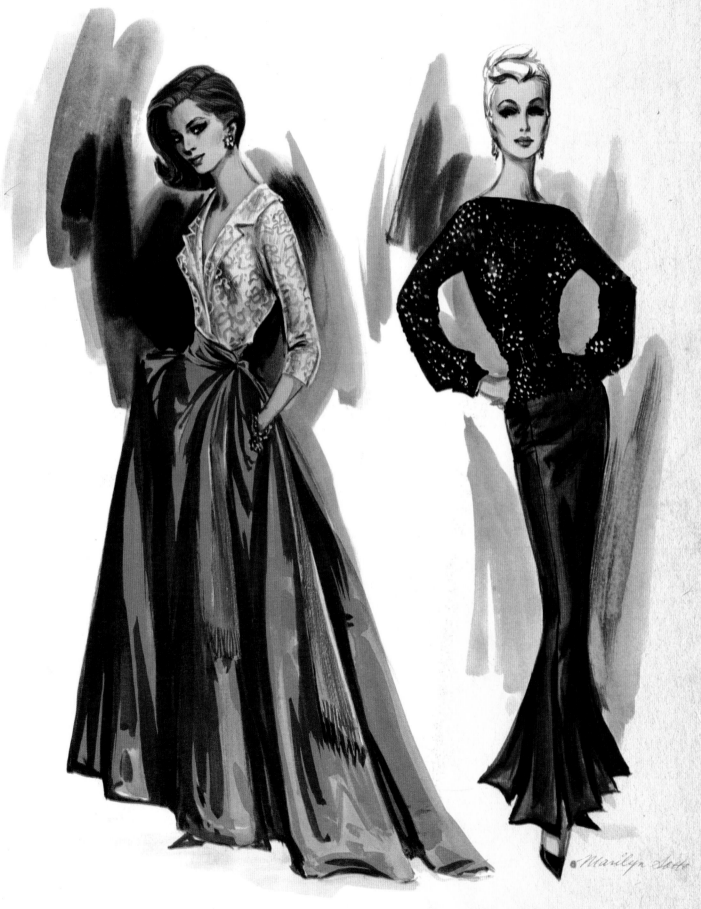

Although both designs are hostess gowns, the figure on the right could also serve as a minimalist dinner gown. In most cases, costumes should not look like costumes, but rather as natural attire to the performers wearing them. They should never detract from the storyline. Quite the opposite, they should be an integral part of it.

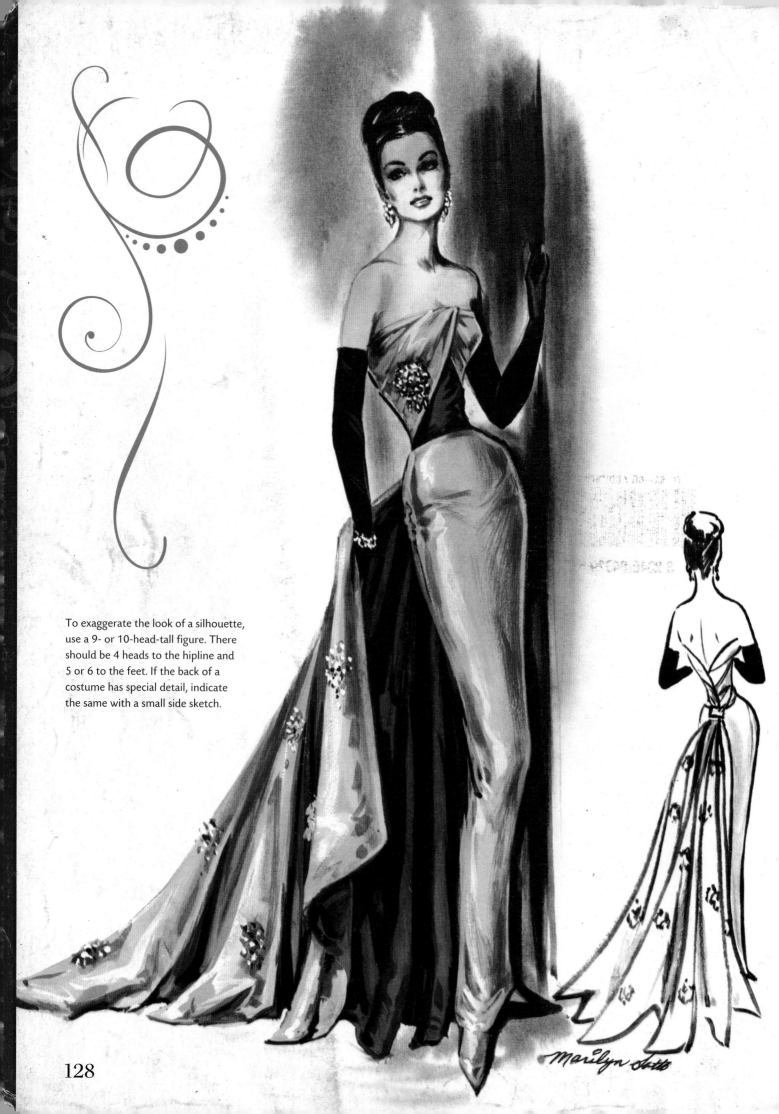

To exaggerate the look of a silhouette, use a 9- or 10-head-tall figure. There should be 4 heads to the hipline and 5 or 6 to the feet. If the back of a costume has special detail, indicate the same with a small side sketch.

128